# CHURCHES OF NORTHERN YORKSHIRE

DAVID PAUL

AMBERLEY

This edition first published 2024

Amberley Publishing
The Hill, Stroud
Gloucestershire GL5 4EP

www.amberley-books.com

British Library Cataloguing in Publication Data.
A catalogue record for this book is available from the British Library.

ISBN 978 1 3981 1697 9 (print)
ISBN 978 1 3981 1698 6 (ebook)

Typesetting by SJmagic DESIGN SERVICES, India.
Printed in Great Britain.

# CONTENTS

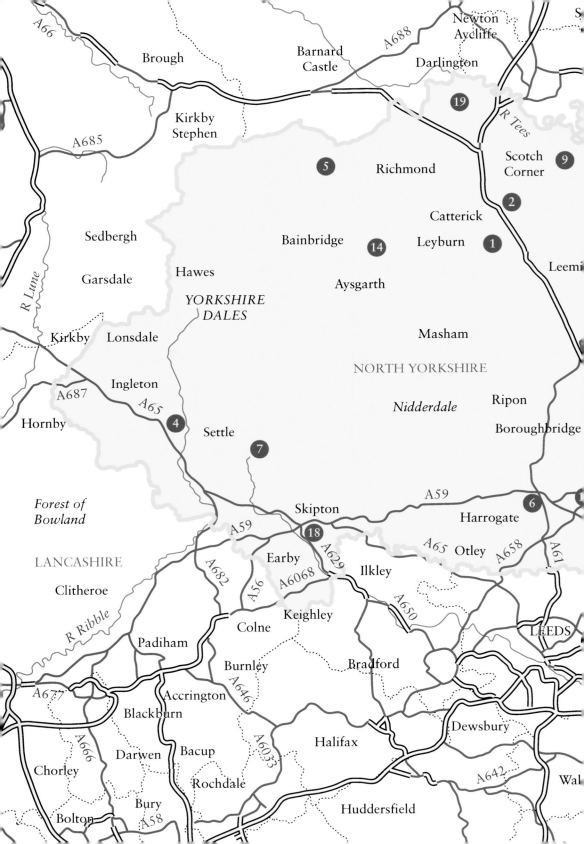

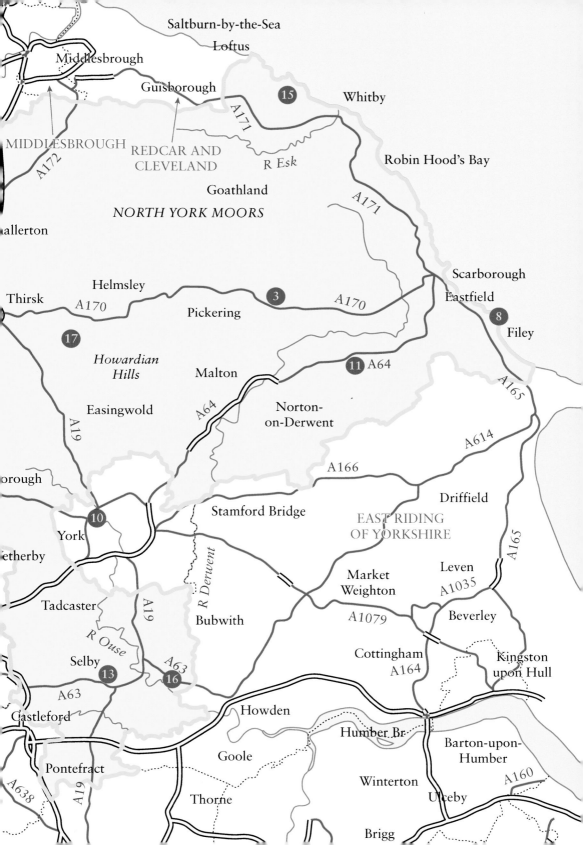

# INTRODUCTION

After spending some time walking through many of the relatively small and isolated villages in Yorkshire's more northerly districts, it is perhaps comparatively easy to understand just why so many of the beautiful churches in this region have become redundant in the busy world of the twenty-first century. But the beauty and harmony that these churches share with the often-rugged countryside is readily apparent.

Yorkshire, as a whole, lists some 175 Grade I listed churches. Nineteen of these churches have been included in this book, which features churches in the northern regions of the county.

Much of the country's social and political history can be found within church records or church architecture. As an example, the benefactors of St Anne's Church, Catterick, drew up a written contract. The document still exists today and is significant in that it is one of the oldest contractual documents written in the English language. It is thought that the main reason for it being written in English rather than the more traditional Latin was so the stonemasons would be able to understand the terms of the contract, though this makes the assumption they could read English. Another example of social history can be seen at St Andrew's Church, Grinton. The church has a so-called chained Bible, which dates from 1752. There is an inscription that states: 'For the use of the inhabitants of Grinton, 1752'. Chaining books in churches was a way for church elders to retain possession of their property. It was also a channel of communication for those who could read. Edward VI later stated that each church should 'provide within three moneths one boke of the whole bible of the largest volume in English … to be sette upp in some convenient place within the churche'.

Social prejudices were also common in earlier times. Many churches had a hagioscope built into their walls, similar to the one at St Peter's Church, Croft-on-Tees. A hagioscope, or 'squint window', was a diagonal opening that was cut through the church wall and enabled lepers and other 'non-desirables' to see the altar, and therefore the elevation of the host, without coming into contact with the rest of the congregation.

The churches detailed in this book have many different styles of architecture, with the earliest dating from the Saxon and Norman periods. The gradual introduction of Gothic architecture, which originated in northern France, replaced the old Norman or Romanesque style of church construction. Three Gothic architectural styles are predominant: Early English Gothic, which dates from around 1180 to 1250 and is characterised by pointed arches or lancets; Decorated Gothic, which was fashionable between 1250 and 1350 and is characterised above all by the tracery on the stained-glass windows; and finally, Perpendicular Gothic,

which dates from around 1350 to 1520 and is characterised by a predominance of vertical lines that are most noticeable in the stone tracery of the windows.

This book does not purport, in any way, to be an academic text, but is aimed at the general reader.

## 1. St Gregory, Bedale

When William the Conquer was consolidating his domination of the entire country, his knights waged a 'scorched earth' campaign in the north of England, aimed at overcoming the resistance being encountered there. The campaign, which was focused on Yorkshire and adjacent shires, became known as the Harrying, and took place during the winter of 1069/70 when entire villages were razed and their inhabitants killed. However, as the church at Bedale is recorded in the Domesday Book, this would suggest that either it was built after the Harrying, or, for some reason, it was saved from the wonton destruction of almost every church between York and Durham.

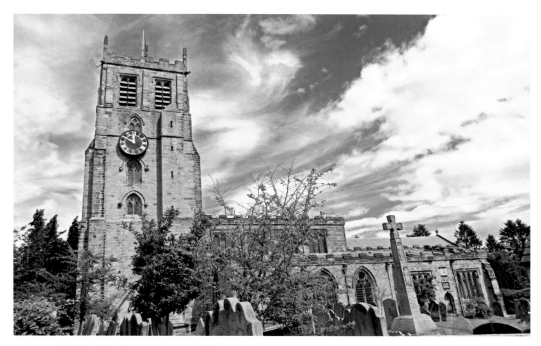

Parish Church of St Gregory, Bedale.

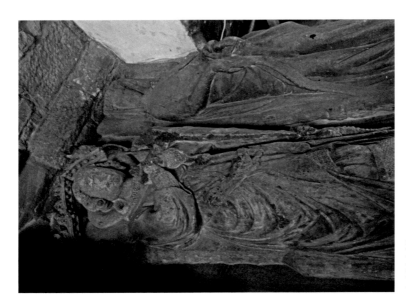

Effigy of Lord
Bedale, Bryan
FitzAlan and his first
wife, Lady Muriel.

It is thought that there was possibly an Anglo-Saxon church on the site as early as AD 850. The Saxon chancel was extended at the beginning of the thirteenth century, and much later in the same century the south aisle added by the Lord of Bedale, Bryan FitzAlan. FitzAlan also endowed a chantry, paying monks from Jervaulx Abbey to say prayers for the soul of his family. When the chancel was extended again in the early part of the fourteenth century, a triple sedilia was built into the south wall. Also, the chancel floor was raised when the vaulted crypt was being constructed. Prior to the crypt being used as a mausoleum, it served as a sacristy.

Although the present church, which is dedicated to St Gregory, dates to the thirteenth century, the nave, chancel extension and the north aisle date to the beginning of the century, whereas the south chapel – the Lady Chapel – and the south aisle were built at the end of the century, with various additions being made at other times.

The tower, with its defensive portcullis, was built in the 1330s by Bryan FitzAlan, and it is thought that following his death Mathilda FitzAlan, his wife, completed the building. The tower stands 98 feet high, and the only objective of the portcullis being incorporated into the structure was to protect townsfolk in the event of marauding forces attacking the town. However, it was a combination of corrosion and a lightning strike in 1830 which eventually brought the structure crashing down. The tower has other unusual features, such as a bedroom and a fireplace, both of which, it can be assumed, were part of Bedale Castle, which at one time was located immediately to the west of the church.

The Beresford-Peirse family gifted the tower's clock to the parish in 1873. There is a sundial on the outside of the south doorway which dates from 1556. A chapel was dedicated to St George when the north aisle was enlarged in 1342, and, at the beginning of the fifteenth century, a clerestory was added in order to allow more light to enter the church.

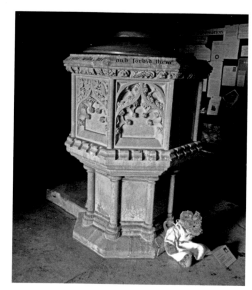

*Right*: Caen stone, Victorian font.

*Below*: East window of the Lady Chapel, taken from Jervaulx Abbey.

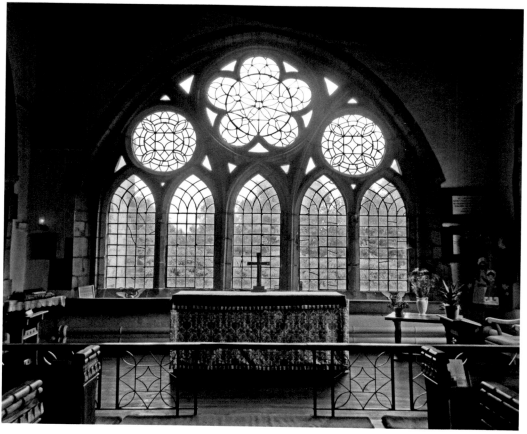

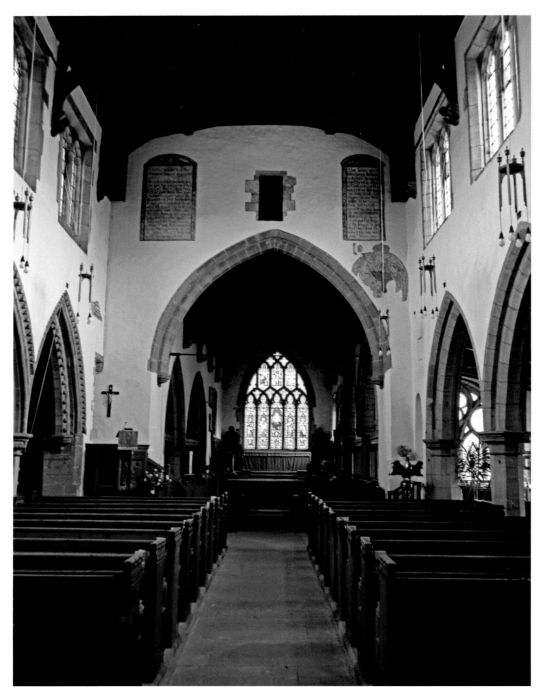

Looking towards the chancel.

The Victorian font, which is directly under tower, is carved from Caen stone. Mounted on the tower wall are the 'Benefaction Boards', which list the bequests made to the church; the bequests are still administered by 'The Rector and Four and Twenty'.

During the restoration of the church in the 1920s, a number of ancient wall paintings were uncovered above the nave, including depictions of the Creed and the Lord's Prayer. In St George's Chapel, there is an unusual depiction of the saint: it portrays St George as being left-handed as he fights the dragon. In all probability, the images were whitewashed over during the restrictions on wall paintings which were imposed during the Reformation.

The Sanctus bell at St Gregory's was cast by Samuel Smith of York in 1713. The church has another eight bells, including what is thought to be one of the oldest bells in the country that rings. The Jervaulx Bell, which was cast by Johannes de Stafford of Leicester *c.* 1360, was brought from Jervaulx Abbey sometime in the latter part of the fourteenth century. Three of the other bells were cast by W. Oldfield between 1625 and 1631, with bells by Thomas Wood of Thirsk and E. Seller being added in 1664 and 1755 respectively. The final two bells were cast at the foundry of John Warner in 1873.

When Jervaulx Abbey was closed during the Dissolution of the Monasteries, what is now the east window of the Lady Chapel in the south aisle was taken to St Gregory's. In order to allow more light to enter the church, the clerestory was added at the beginning of the fifteenth century, having four windows on either side of the aisle.

The stonework of the five-light east window was brought from Jervaulx Abbey at the time of the Reformation, and the windows themselves, designed by William Wailes, are Victorian. The other stained-glass windows in the church also date from the Victorian era.

The Stapleton family and the de Grey family held the manor of Bedale after the FitzAlans, and their respective coats of arms can be seen over the east window.

There are several memorials and effigies in the church, including two fifteenth-century effigies of knights on the south side of the tower and another two effigies on the north side of the tower arch. It is not known who the effigies are of on the south side of the tower, but those on the north side are of the Lord of Bedale, Bryan FitzAlan and his first wife Lady Muriel. The black marble grave slab of Thomas Jackson, a Bedale merchant who died in 1529, is set into the floor of the north aisle. In the north chapel there is an effigy of Brian de Thornhill, who was the third rector of St Gregory's from 1298.

Gustavus Katterfelto, who was a Prussian conjurer and scientific lecturer, is also buried in the church, near to the altar.

In 2003 a carved piece of a Viking hogback gravestone depicting the Norse god Weyland was discovered in the church crypt. The Wayland Stone, as it is now known, was carved at a time when there was a transition from Pagan to Christian beliefs, as there are both Pagan and Christian symbols carved in the stone.

The war memorial, which was originally constructed in 1920 as a memorial to those who lost their lives in the First World War, is now dedicated to all who gave their lives in both of the world wars.

**Location: DL8 1AA**

## 2. ST ANNE, CATTERICK

It is thought that there was a religious foundation at Catterick as early as the seventh century, although this cannot be verified. The present church, dedicated to St Anne, was consecrated in 1415.

There is a record in the Domesday Book noting that there was a church in Catterick, the Ecclesia de Catrice. It is a widely held belief that in the seventh century St Paulinus was baptised and converted to Christianity in the nearby River Swale. Also, in the same century, at least two Anglo-Saxon kings of Northumbria were married at Catterick: Æthelwald Moll of Northumbria and Æthelred I of Northumbria.

During Anglo-Saxon times it was common practice to place a plain cross upon a designated a holy site rather than have a permanent church building. The current

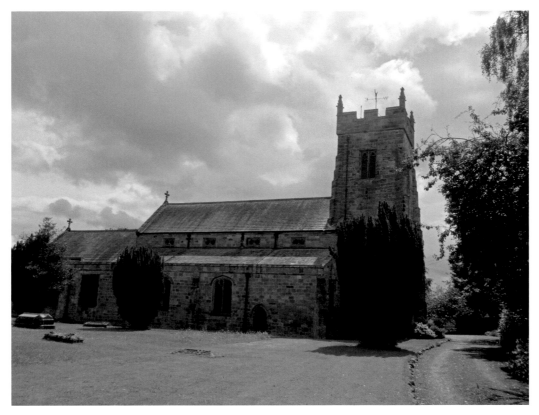

Parish Church of St Anne, Catterick.

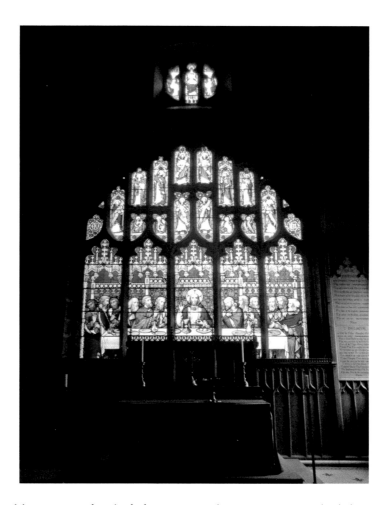

East window by
William Wailes,
depicting the Last
Supper.

church does indeed have part of a shaft from an Anglo-Saxon cross, which has now been incorporated into the west wall of the north aisle.

The benefactors of the church were Dame Katherine de Brugh, wife of John de Burgh of Catterick, and their son William. William became a patron of the church after the death of his father. A written contract, which still exists, was drawn up between the de Burgh family and their stonemason, Richard of Cracall (Crakehall). The document is significant in that it is one of the oldest contractual documents written in the English language. It is thought that the main reason for the document being written in English, rather than the more traditional Latin, was so that the stonemason would be able to understand the terms of the contract. Although Cracall was given some latitude in the construction of the building, most of the clauses in the contract were very precise, especially those relating to the completion date of the church, which was to be no later than Saturday 24 June 1415, the Feast Day of St John the Baptist. The contract contained one significant caveat which stated: 'Unless sudden war or pestilence should afford

sufficient excuse for delay.' There is a note on the reverse of the contract which states that John de Burgh, William de Burgh and William's son are all buried in the church.

The original church, as detailed in the written contract, had a north and a south aisle, a nave and a chancel. And, although not part of the original contract, provision was made for the addition of a steeple. The vestry, porches and tower were added later in the century, and, mostly, attributed to Richard of Cracall.

Following the death of William de Burgh in 1442 his grandson, also called William, extended the north nave aisle where William had been buried, and created the Chantry of St James. In the latter part of the fifteenth century two chantry chapels were added, thus creating provision for the burials of other members of the de Burgh family.

Inscriptions on the octagonal font are the coats of arms of many of the leading families of the locality, including the de Burghs, the Scroops, the Nevilles, the Fitzhughs and the Lascelles.

The church contains many plaques, brasses and monuments, including an effigy of Sir Walter Urswick. Sir Walter fought on the side of the Black Prince at the Battle of Nájera on 3rd April 1367.

The church has suffered damage in both the English Civil War and the Second World War.

In 1658, Revd Michael Syddall, vicar of St Anne's from 1649 until his death in 1658, invested £45 per annum to fund a hospital and school. The school building

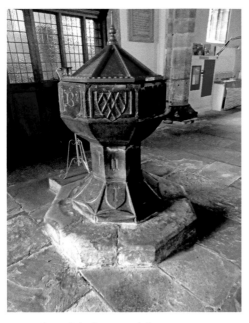

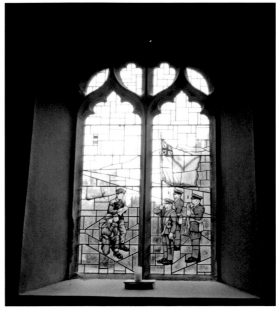

*Above left*: Octagonal font.

*Above right*: Window in the Royal Air Force chapel.

was in use between 1685 and 1974. There is a newer local primary school which is also called the Michael Syddall School. Revd Syddall also provided almshouses for six poor widows of the parish.

Alexander John Scott was appointed vicar at St Anne's in 1816. Previously Scott had served as Horatio Nelson's personal chaplain at the Battle of Trafalgar and had administered the last rites when Nelson was fatally wounded.

In 1851 the church doors were replaced and the pews were made into a uniform standard. This work was carried out under the direction of Atkinson's of York. Further refurbishments were made in 1872 when, under the direction of the architect C. G. Wray, adjustments were made to the clerestory.

The east window, which was installed in 1862, is the work of William Wailes and depicts the Last Supper. The Victorian stained-glass designer and manufacturer Charles Eamer Kempe installed windows in the church in 1896 and 1900.

A section of the church is dedicated to RAF Fighter Command No. 13 Group, which was based nearby at RAF Catterick. The Royal Air Force Regiment Chapel is on the north side of the church. The chapel has a north-facing window which commemorates all serving personnel who have died whilst serving in the RAF Regiment. The stained-glass window has right and left panes which are inscribed with memorial texts and badges.

Many of the graves in the churchyard – 127 in total – date from the two world wars. There is a memorial on the north wall of the church commemorating the war dead from two of the squadrons that were based at Catterick during the Second World War, RAF No. 26 Squadron and RAF No. 41 Squadron.

**Location:** DL10 7LN

## 3. ST PETER AND ST PAUL, PICKERING

The first church to be built on this site was during Anglo-Saxon times. Although little is known about this church, the stone font and a carved cross shaft can still to be seen. The first church was built the towards the end of the twelfth century. Further additions were made which included the north aisle in 1150 and the south aisle, which was constructed just before the turn of the century. The tower, which was situated at the centre of the building, collapsed in the year 1200 and was replaced with a new structure which was built at the west end of the church, with a spire being added sometime later.

The church, as can be seen today, has a nave, two chapels off the chancel, crossing and transepts. There are north and south aisles together with clerestories, a south porch and a west tower with spire.

Sir William Bruce established the first chantry chapel in 1337. There is a stone effigy of Sir William, in full armour, immediately beside the lectern. Sir David and Lady Margery Roucliffe added the second chantry chapel on the south side of the chancel in 1407; their alabaster effigies are against the south-west wall. An eighteenth-century wooden pulpit, following the Hepplewhite style, is also to be found in this chapel. There is a memorial to Mary, Nicholas and Robert King in the sanctuary. The memorial bears both the British and American flags,

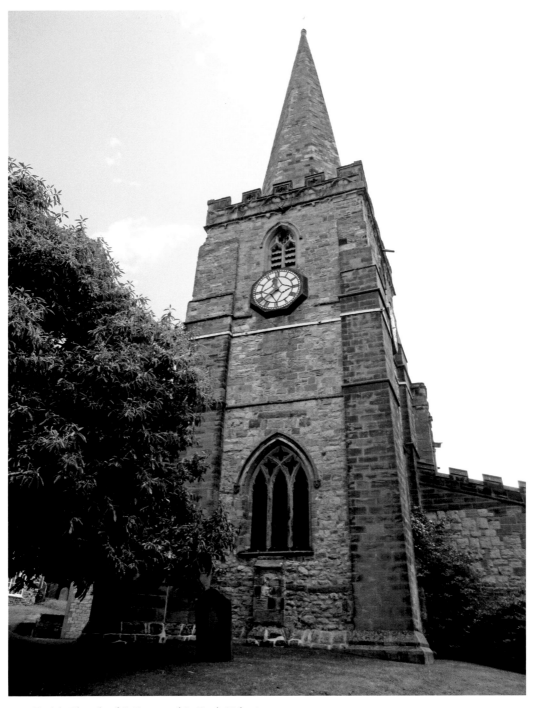

Parish Church of St Peter and St Paul, Pickering.

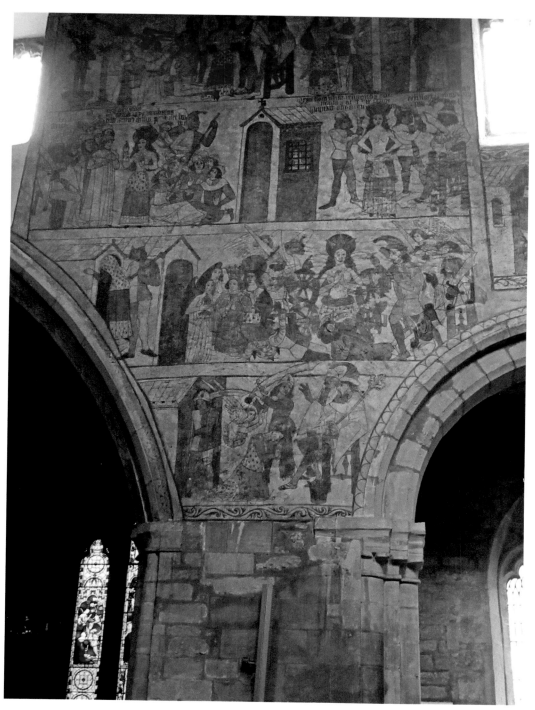

Ancient wall paintings first commissioned in the 1470s.

commemorating the fact that Nicholas and Robert King had surveyed the city of Washington.

However, it is the wonderfully preserved ancient wall paintings occupying the spaces above the nave arches on both sides of the church that capture the imagination and history of the building. It was originally thought that the medieval wall paintings were first commissioned sometime in 1450, but later detailed information contributed by Royal Armouries related to the costumes and armour suggests that the paintings had been commissioned in the 1470s.

The paintings are acknowledged to be among the finest church wall paintings still in existence in the country. However, during the time of the Reformation the paintings were covered over. Many years later, in 1852, when the nave was being cleaned and refurbished, the paintings were rediscovered when some of the covering plaster was accidentally dislodged from the wall. The discovery caused a degree of friction between the vicar of the parish, Revd John Ponsonby, who was a very conservative cleric and abhorred the thought of any a Catholic imagery in the church, and the Archbishop of York, Dr Thomas Musgrave.

Revd Ponsonby declared that they distracted his flock from his sermons and subsequently wrote to the archbishop declaring 'as a work of art they are fairly ridiculous, would excite feelings of curiosity and distract the congregation'. He

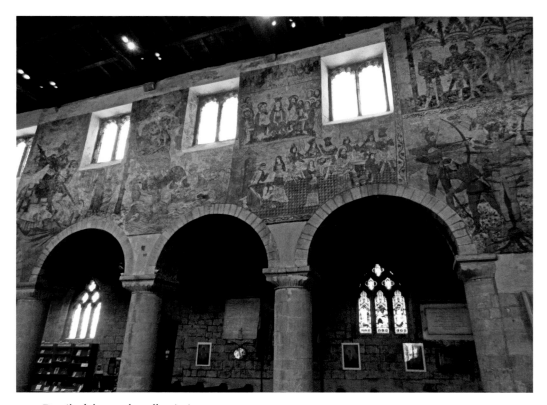

Detail of the north wall paintings.

The Anglo-Saxon carved stone font.

then asserted that 'the paintings are out of place in a protestant Church, especially in these dangerous times'. Within a fortnight of the discovery he had the paintings re-covered in a thick yellow wash, much to the chagrin of the archbishop and the dismay of many parishioners.

During the 1870s a major programme of restoration and refurbishment was carried out at the church under the direction of Manchester architect Joseph Stretch Crowther. The old box pews were replaced with oak pews; the transepts were rebuilt; the galleries in both the north transept and west end were removed; and a new organ and heating system were installed. The church tower was also underpinned following advice and guidance from Sir George Gilbert Scott.

In 1882, when the refurbishments had finally been completed, the new vicar, Revd George Herbert Lightfoot, decided that the now covered paintings should be restored to their former prominence. Fortunately, W. H. Dykes, an assistant architect at Durham Cathedral, had made accurate drawings of the paintings before they had been covered, and these drawings were used by artist Edward Holmes Jewitt and craftsmen from the firm Shrigley and Hunt of Lancaster to restore the paintings. Further conservation work was carried out in the 1930s by the wall painting artist Ernest William Tristram, and later by his protégé, the archaeologist Edward Clive Rouse.

Covering the greater part of the nave walls, the paintings depict scenes from the Lives of the Saints, the Seven Corporal Acts of Mercy, the Passion and the Resurrection of Christ, and the Harrowing of Hell.

The paintings on the north wall start with a depiction of St George on horseback slaying the dragon, followed by St Christopher carrying Christ as a

*Left*: The late eighteenth-century
Hepplewhite-styled pulpit.

*Below*: The rood screen, leading to the chancel
and sanctuary.

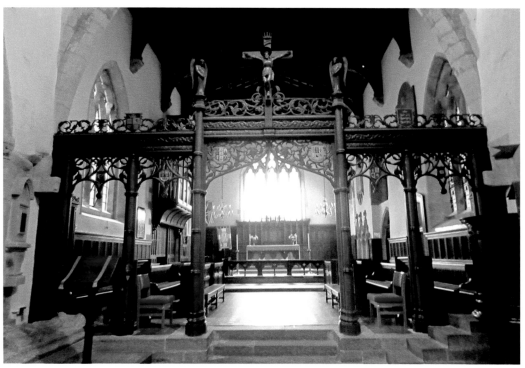

child across a river with serpents around his feet – the significance of the paintings being that these saints could offer protection from disease, sudden death and other misfortunes. The story of St John the Baptist is then shown, with him being beheaded and his head then offered to Salome.

Above is a scene of the Assumption and Coronation of the Virgin being crowned in Heaven by God the Father. Next is a scene depicting the martyrdom of Thomas Becket by four knights. Another martyrdom, that of St Edmund, is shown below.

The paintings on the south wall start with a depiction of the life of St Catherine of Alexandria. The final painting in the story of St Catherine shows her kneeling while being blessed by an angel as her executioner raises his sword. The Seven Corporal Acts of Mercy are shown in the next long painting. Next comes scenes from the Passion and Crucifixion of Christ. The jaws of Hell are also shown, with sinners being pushed into the mouth of a monster. Finally, there is an image showing the Resurrection of Christ.

**Location:** YO18 7BE

## 4. St Alkelda, Giggleswick

The Church of St Alkelda, Giggleswick, dates largely from the fourteenth and fifteenth centuries, although it is thought that there has been a church on this site since Saxon times. It is considered that the earlier church was destroyed at the beginning of the fourteenth century by marauding Scots. Between 1890 and 1892, Paley, Austin and Paley, architects of Lancaster, restored much of the church. Further restorations were made during the early part of the twenty-first century.

The first reference to there being a church in Giggleswick was made by Laurentius persona de Guckilswic in 1160, when the site was mentioned in a letter written to William de Percy. There are only two churches that are dedicated to St Alkelda, the other being in Middleham, which is also in North Yorkshire. Local legend would suggest that Alkelda, who it is thought was a nun and also an Anglo-Saxon princess, was strangled to death by pagan Viking women while journeying between Middleham and Giggleswick sometime in the ninth century, at the time of the Danish raids at Middleham.

In 1200 Henry de Puteaco gave the church at Giggleswick to the monks at Finchale. The church remained under the jurisdiction of the Benedictine priory until thirty years before the Dissolution of the Monasteries.

The church's architectural style is a mixture of Early English and Perpendicular. St Alkelda's has a south porch, a three-stage west tower and a five-bay nave. There are also north and south aisles with single-bay north and south side chapels and a one-bay chancel. The tower was added during the fifteenth century. The tower's second stage has a string course and a single-light chamfered window with trefoil head. The tower has an embattled parapet and crocketted finials. The clock face is on the east side of the tower.

There is an alms box on a pillar in the south arcade, which dates from 1684 and is inscribed 'Remember the Pore'.

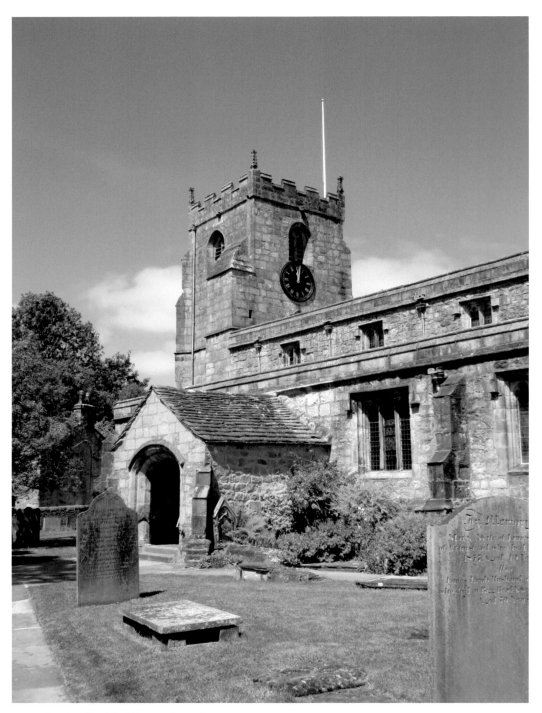

Church of St Alkelda, Giggleswick.

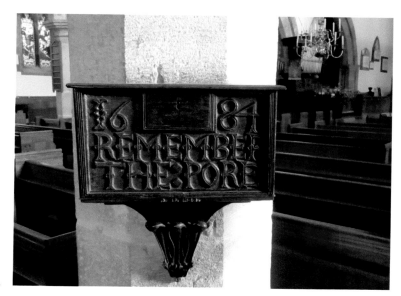

Alms box
dating to 1684.

The reading desk and two-decker pulpit date to 1680. The two-decker pulpit was previously a three-decker pulpit.

The nave has four two-light windows with hood moulds to the clerestory. There are three-light windows in the side aisles with hood moulds, and there is also a brass candelabra dating to 1718 in the nave.

There has been much renovation and conservation of the fifteenth-century stained glass found in the church. Early in the twentieth century a stained-glass window was discovered which depicted St Alkelda being strangled while she was held over water – possibly a holy well. The panel was found by two members of the church's congregation and, initially, it was thought that the glass was a representation of an angel, but on further, more detailed, examination it was decided that the panel was a depiction of St Alkelda. Parishioners raised funds in order that the glass panel could be cleaned and restored. A faculty was sought so that the panel could be installed in the church. However, in order to verify the provenance of the glass panel, in 2017 it was taken over to York Minster so that their expert glass conservationists could examine it and perhaps shed further light on the origin and history of the panel. But, following exhaustive examination, rather than being ancient glass, as was first thought, it was suggested that the panel dated from the 1920s or 1930s and that there was evidence in the composition of a definite art nouveau influence.

The early fifteenth-century font has an octagonal base and is located at the rear of the church, near the entrance.

Abbott and Smith, the church organ builders from Leeds, built and installed the organ in 1892. The organ was extensively renovated in 2005.

On the north wall there is a marble memorial by Leyland and Bromley to George Birkbeck. Birkbeck was a British physician, academic and philanthropist.

*Left*: Fifteenth-century font.

*Below*: Looking towards the sanctuary.

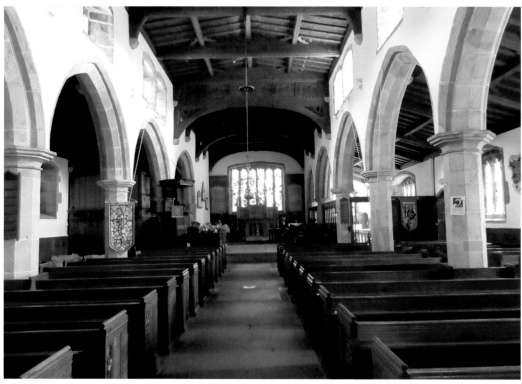

He was also a professor of natural philosophy and an early pioneer of adult education; perhaps his most notable achievement is as the founder of Mechanics' Institutes.

St Alkelda's feast day is celebrated on 28 March, although 5 November is also a contender.

In a 'green initiative' the church installed solar panels on the roof in 2020 in order to save energy and reduce its carbon footprint.

The war grave of Lieutenant Gerald William Ackroyd Simpson of the Royal Army Ordnance Corps is in the churchyard. Lieutenant Simpson died on 26 January 1919.

**Location:** BD24 0BE

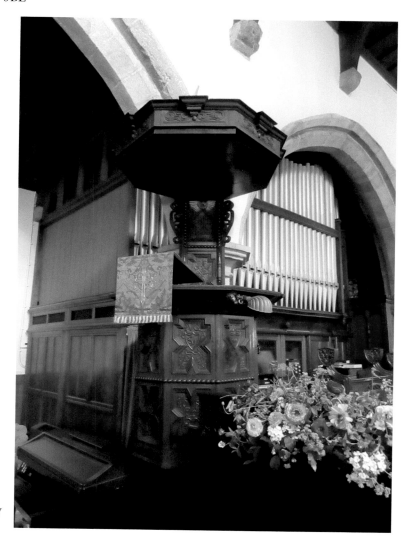

Seventeenth-century two-decker pulpit.

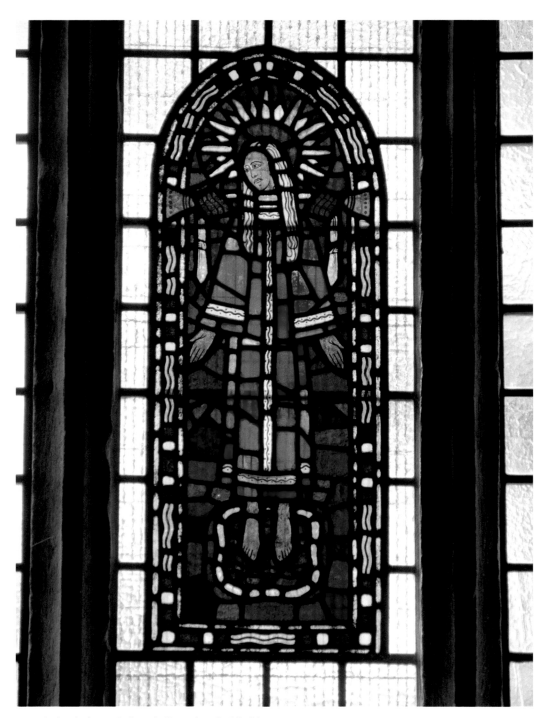

Stained-glass window dedicated to St Alkelda.

## 5. ST ANDREW, GRINTON

The Norman Church of St Andrew was built in the twelfth century, although there have been a number of alterations made in subsequent centuries. There is also evidence to suggest that before St Andrew's was built a Saxon place of worship had existed on the same site. Being the only church in the area for almost 400 years, St Andrew's had the distinction of being the largest parish in Yorkshire; it is still often referred to as the 'Cathedral of the Dales'.

In the twelfth century much of the land around Grinton was owned by the Augustinian Bridlington Priory, the land having been given to them by William de Gaunt. When the church was built later in the century, it too was given to the Augustinian priory and, subsequently, the monks became responsible for the worship and upkeep of the church. During that period the church was referred to as Ecclesia de Swaledala. It was not until the thirteenth century that a vicar was appointed, who assumed the role of parish priest. At the time of the Dissolution of the Monasteries the church fell under the jurisdiction of the Crown, and this state continued until 1890 when the church became the property of the Bishop of Ripon.

There were many additions made to the church in the thirteenth, fourteenth, fifteenth and sixteenth centuries, and there have been other modifications since that time.

St Andrew's has a west-facing tower, north and south aisles, a nave, north and south chapels, a chancel, a vestry and a south-facing porch.

Parish Church of St Andrew, Grinton.

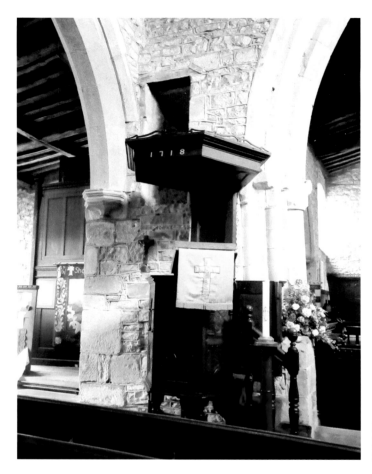

Dating to 1718, the
Jacobean pulpit with
sounding board.

Among the many ancient artefacts within the church is a chained Bible, dating from 1752. There is an inscription that states: 'For the use of the inhabitants of Grinton, 1752'. Chaining books in churches was a way for church elders to retain possession of their property. It was also a channel of communication for those who could read. Henry VIII decreed that churches should have one chained Bible on show. Edward VI then stated that each church should 'provide within three moneths one boke of the whole bible of the largest volume in English....to be sette upp in some convenient place within the churche'.

In addition to the chained Bible, St Andrew's has the Clarkson memorial in the churchyard and the gates and gate piers to the east of the church, all of which are Grade II listed.

Similar to many other churches in the region, St Andrew's has a hagioscope or 'squint window' in the south-west wall. This diagonal opening went through the wall and enabled lepers and other 'non-desirables' to see the altar, and therefore the elevation of the host, without coming into contact with the rest of the congregation. The 'squint' was often referred to as the 'leper-hole'.

The clerestory has a number of windows in the south side, but there are none in the north side. There are fragments of fifteenth-century stained glass in the east window. The Jacobean pulpit in the nave was fitted with a sounding board dating to 1718. St Andrew's has a circular twelfth-century font with a chevron-design Perpendicular Gothic cover.

There is a Jacobean screen made from a section of an old squire's pew in the south aisle, and in the north aisle there is a wall monument to Thomas Peacock and family by Davies of Newcastle-upon-Tyne. There is also a wooden wall memorial to Edward Elliott and several floor slabs.

The architect William Searle Hicks of Newcastle-upon-Tyne was responsible for oversight of the refurbishments made during 1895 and 1896. The box pews were replaced by more traditional pews, and a number of new stained-glass windows were installed, including one by the celebrated stained-glass artist Charles Eamer Kempe, although many of the original medieval stained-glass windows were retained. During these renovations there was also a new clock installed on

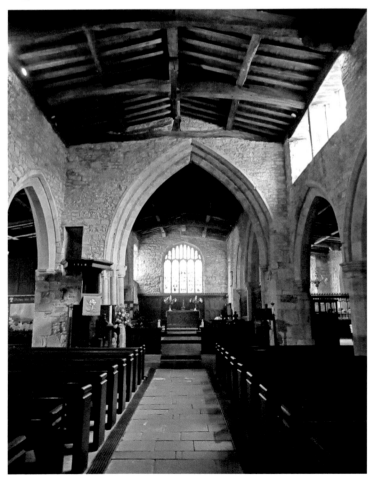

Looking towards the chancel.

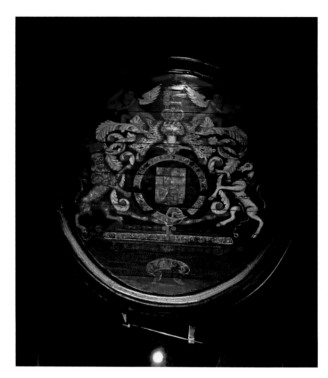

*Left*: Royal arms of William and Mary, dating to 1693.

*Below*: The hermit's cell, or anchorage, added towards the end of the fifteenth century or early in the sixteenth century.

the church tower and the church bells were re-cast. The three-train clock was manufactured by Potts of Leeds. St Andrew's was reopened at Easter in 1896.

Two new bells, cast at the bell foundry of Taylor's of Loughborough, were recently installed in the tower at St Andrew's, and for the first time in its long history the church now has a peal of eight bells. As St Andrew's is the principal performance venue for the Swaledale Festival – the event organisers wished to arrange a suitable commemoration of the event. On Friday 9 June 2017 a special quarter peal of Grandsire Triples was rung, having 1,260 changes and taking some forty-five minutes.

During the medieval period St Andrew's served a huge area, and for much of that time it was the only local church to have a burial ground. It was necessary to carry corpses for burial from as far afield as Keld, a distance of some 16 miles. The track that linked all of the outlying villages and hamlets with Grinton became known as the 'Corpse Way'.

For many years the church has played host to a protected species of bats.

**Location:** DL11 6HW

## 6. St Wilfrid, Harrogate

St Wilfrid's Church, Harrogate, a 'Major Parish Church', was designed by the English architect Temple Lushington Moore and is probably his most famous work. Temple Moore was an Anglo-Catholic by persuasion, and this conviction is reflected in his approach to the design of the building and the wishes of the local populace.

Following a bequest of £3,485 from the estate of the late Bishop of Ripon, construction of the church was able to start. The foundation stone for the new church was laid in 1904. The nave and baptistry were dedicated by the Bishop of Knaresborough on Saturday 4 January 1908. Subsequently, the church was consecrated on Thursday 11 June 1914 by the Bishop of Ripon. Then, on Sunday 24 August 1914, the first congregation assembled in a corrugated-iron building in a corner of the building site. It is estimated that the total cost of building the church amounted to £24,000.

Many residents of the affluent duchy estate contributed to the building of a new Anglo-Catholic parish church at Harrogate. One of the residents, Elizabeth 'Bessie' Trotter, devoted much of her time and energy to the raising of funds to build the church. In 1902 Elizabeth had been travelling from London to Scotland with her sister Jean. The sisters decided to take a break from their journey at Harrogate and later that evening, whilst at prayer, Jean Trotter unfortunately died. It was then that Elizabeth made the decision to settle permanently in the town and devote herself to raising money for the new church in honour of her dead sister. In 1924, a bequest of £32,000 from Jean Trotter enabled the north and south transepts to be completed in 1927. The church's architect, Temple Lushington Moore, had died in 1920, but the work was completed by his son-in-law, Leslie Moore. The following year the organ was installed in the north transept and, on Wednesday 18 July 1928, the organ and transepts were dedicated by the Bishop of Oxford.

A bequest of £9,000 left in the will of William Gunn enabled the church hall to be built in 1932. The hall has a unique lamella roof. Although much of the

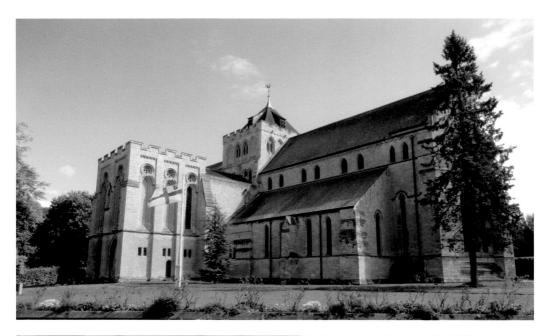

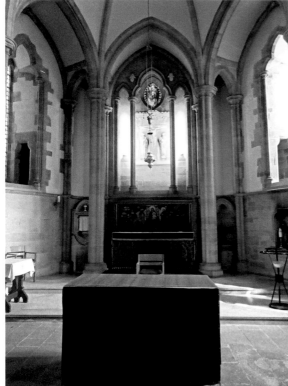

*Above*: Parish Church of St Wilfrid, Harrogate.

*Left*: Lady Chapel.

building of the church had now been completed, in 1935, through Sir William Nicholson's generosity, the Lady Chapel was built at a cost of £10,000. However, Leslie Moore's design was radically different from the small chapel formerly proposed by his father-in-law.

The impressive rood screen has carved depictions of Our Lord on the Cross, flanked by Our Lady and St John the Evangelist.

The bas-relief panels on the nave walls were created by Frances Darlington, who had studied sculpture in London at the progressive Slade School of Art.

Fashioned from Verona marble, the font at St Wilfrid's has a stunning 1960s sculpture above showing flames and a dove descending from Heaven, symbolising the Holy Spirit.

There are many very impressive stained-glass windows in the church, including windows by Francis Stephens, Harry Harvey and Victor Milner. The church's panelled pulpit was designed by Temple Lushington Moore. There is a poignant memorial brass set into the nave floor. The memorial commemorates Harold Hornsby of Keble College, Oxford. Harold was a server in St Wilfrid's but tragically lost his life by drowning in Oxford on 19 June 1911.

St Wilfrid's has always had a strong choral tradition and, in 2015, a Music Foundation was established in order to enhance the musical life of the parish.

St Wilfrid's has a total of three organs, the main one being the pipe organ that was built and installed in 1928 by Harrison & Harrison, the organ builders of Durham. The company has been responsible for the organ's upkeep and maintenance since that time. At the beginning of the twenty-first century a full restoration of the organ became necessary.

When the Gray and Davidson chamber organ at the Stockport Christadelphian church became redundant at the end of the last century, it was acquired by St Wilfrid's. The one-manual organ dates from 1849. The third organ, the

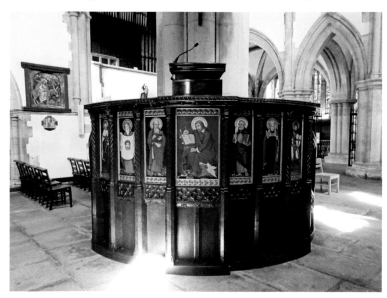

Pulpit designed by Temple Lushington Moore.

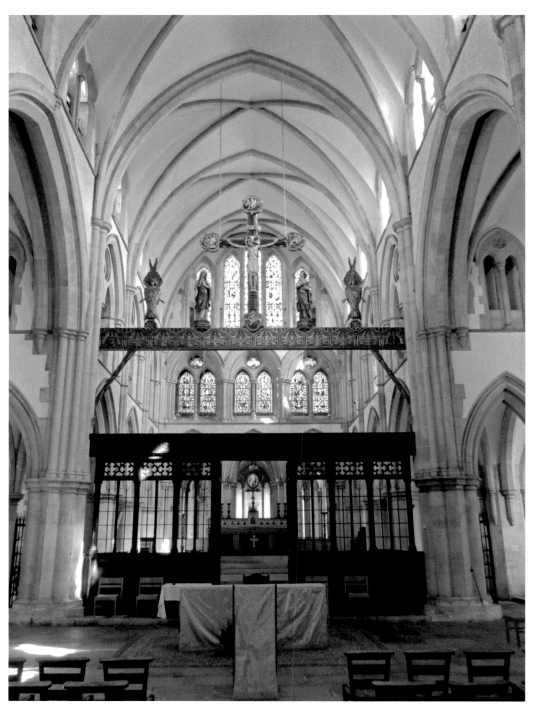

Rood screen.

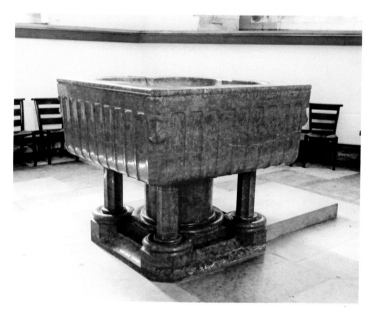

The font is fashioned from
Verona marble.

four-manual Phoenix Digital organ, was purchased from Newcastle Cathedral in 2021 and is used for most services at St Wilfrid's.

The ring of eight bells at St Wilfrid's was all recast from redundant bells at All Hallows, High Hoyland; All Saints, Sculcoates; and St Clements, Sheepscar. Towards the end of the nineteenth century, when All Hallows was demoted to a chapel of ease, the church's six bells became redundant as they were only used infrequently. The bells were offered to St Wilfrid's and, following recasting in 1972, the bells were hung as a new ring of six at the church. Then, in 1964, when most of the bells in the tower of All Saints' Church, Sculcoates, were sold as scrap, the treble was recast to become the new second at St Wilfrid's. Finally, in 1975 when St Clement's in Sheepscar was closed, the church's single bell was recast as the treble for St Wilfrid's. The ring of eight bells at St Wilfrid's was completed in 1977. There is also a Sanctus bell in the tower.

A First World War memorial is in the form of a painted triptych, which has a central panel that depicts St George slaying a dragon.

**Location:** HG1 2EY

## 7. St Michael the Archangel, Kirkby Malham

It is thought that this church dates from the ninth century, but there is the possibility that the first church actually dates from the seventh century when St Oswald, king of Northumbria, and his bishop, St Aidan, were making their missionary journeys to the north.

As there is no mention of the church in the Domesday Book, the clear implication is that, like the village itself, the church was razed to the ground when William the Conqueror ravaged the north of England.

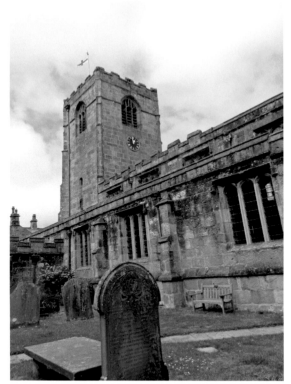

*Above*: Discarded font.

*Left*: Church of St Michael the Archangel, Kirkby-in-Malhamdale.

In a charter dating from 1199, King John confirmed the gift of the Church of St Michael the Archangel and its glebe land by Adam de Giggleswick to the Abbot and canons of the Premonstratensian Abbey of Our Lady at West Dereham, Norfolk. The order then supplied the parish with its clergy until the Reformation.

In a will that dates to 1275, the parish church of Kirkby Malham is referred to as St Michael the Archangel, although in the nineteenth century a number of guidebooks refer to the village church as being dedicated to St James. In fact, the Ordnance Survey of that time also refers to it as St James'.

The church was almost completely rebuilt early in the fifteenth century. Then, between 1879 and 1881, St Michael's was restored under the instruction of Walter Morrison of Malham Tarn House. The restoration work was directed by the firm of Lancaster architects Paley and Austin. The predominant architectural style is perhaps best described as being rustic Perpendicular Gothic. The church has a clerestory which was designed to admit more light to the nave.

At the time of the Dissolution of the Monasteries, the Bolton Priory estates at Malham and Calton passed into the hands of the Lambert family, as did the Lady Chapel of St Michael's which had an association with Bolton Priory. The Lambert memorial can be seen in the Lady Chapel. Following the restoration of the chapel a commemorative tablet was dedicated to the memory of John Lambert in 1984.

Family box pew.

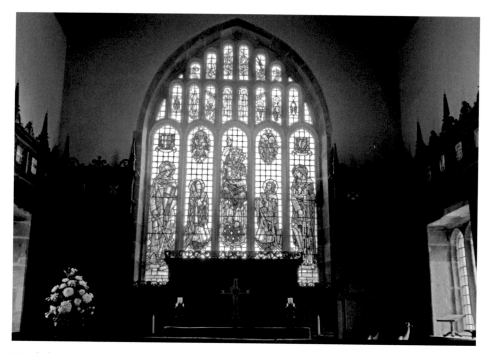

Five-light east window.

Lambert was a General of the Parliamentary Army of the North at the time of the Civil War.

The church has a four-bay nave with a clerestory, together with both north and south aisles. Both of the aisles have side chapels, the south chapel being known as the Lady Chapel, and the north chapel being dedicated to St John the Baptist. The Lady Chapel has a doorway on the west side and a three-light window on the east side. The St John the Baptist chapel has a three-light east window. There is also a two-bay chancel and a two-stage west tower with a three-light west window. The tower has clock faces on the east and west sides, with three-light bell openings on each side. There is an embattled parapet at the summit. St Michael's also has a south porch and a north hearse house.

There is a magnificent five-light stained-glass window in the east wall of the chancel. Four coats of arms are carved on the south-west buttress of the tower. One is unknown, although the other three are the arms of the Bankes of Bank Newton, the Malhams of Calton and the Tempests of Broughton. It is thought that these families were benefactors of the church at the time of the rebuilding.

The clock tower was manufactured by Potts of Leeds and dates to 1881. The clock replaced an earlier blacksmith-made clock. The tower itself dates from 1495.

Up until the sixteenth century it was not unknown for the Scots to raid isolated villages in the north of England. On these occasions the church became a place of refuge. Whenever there was a raid a sturdy oak beam would be drawn across the inside of the door, rendering the church as a place of sanctuary.

The original font dates to sometime before the seventeenth century. It was at that time that it was replaced by the font that is now used as a planter, which can be seen outside the church near to the porch. The discarded font was used for many things, including serving as a pig trough for some years before being rescued and returned to its rightful place in 1881. A fragment of a pre-Reformation altar is preserved in the vestry. The fragment shows four of the five crosses that symbolise the five wounds of Christ. Near to the vestry is a blocked-up door that is known as the Devil's Door. In earlier times whenever there was a baptism the door was opened, so any evil spirits could be driven out by the Holy Spirit.

Set into the floor of the baptistry are three thirteenth-century priests' stone coffin lids.

Since 1951 the niche above the porch door has been occupied by a terracotta sculpture of St Michael. Directly above that is a vertical stone sundial.

The so-called muniment chest, made sometime in the fourteenth or fifteenth century, held important church documents and liturgical vestments. Keys to the three locks were held by the vicar and the churchwardens – all three were required to be present in order to open the chest.

The high-backed churchwardens' pews, dating to 1723, are located at the back of the church near the south entrance. The purpose of the high backs was to shield the wardens from any draughts coming into the church.

The parish registers are said to contain two signatures of Oliver Cromwell, at least one of which appears to be in the Protector's own handwriting.

The accounts books of the churchwardens', which date back to 1723, make for interesting reading. For instance, in 1723, 13s was paid 'ffor 13 ffox heads'. Also in that year, Richard Walker, a dog whipper, was paid 5s for his services.

Originally St Michael's had a ring of three bells. Then, in 2002, the bells were re-hung and augmented to eight bells. On 19 July 2002 the new set of eight bells was rung the first time. The bells were hung by Eayre and Smith and dedicated by the Archbishop of York on 6 October 2002.

*Above left*: Muniment chest.

*Above right*: Statue of St Michael above the porch door.

*Right*: The high backs on the churchwardens' pews protected them from draughts.

The first bell was cast by William Oldfield the Elder in 1602, with the second bell being cast at the same foundry in 1617. The third bell was cast at the foundry of Robert Dalton of York in 1785. The fourth bell was originally cast by John Warner & Sons Ltd, London, in 1897. The other bells were all cast at the Royal Eijsbouts foundry, Asten, Netherlands, in 2002.

In 1923, the panelling that surrounds the sanctuary was erected in memory of the late Dr Walter Morrison. It was following the timely assistance and intervention of Dr Morrison in 1881 that the church was restored and saved from dereliction.

Towards the end of the 1980s the midnight chime of Christmas Eve, known as 'the Virgin's Chime', was restarted. It appears that the chime, which requires the ringers to manipulate the tongues of the bells with their hands, originated in pre-Reformation days, suggesting that the tower might have had bells from the time of its erection.

The church plate includes a chalice given by James Ward of Ravenflat and made at York, by Sem Casson, in 1632. The Ward family pew stands in the chantry of St John the Baptist.

**Location:** BD23 4BS

## 8. St Oswald, Filey

Prior to the Norman Conquest, Tostig Godwinson, who was an Anglo-Saxon Earl of Northumbria, owned the manor of Falsgrave. He and his wife Judith were followers of the cult of Oswald – hence the church subsequently being dedicated to the Northumbrian King Oswald. After the Conquest William gifted the land to the de Gant family, who established Bridlington Priory early in the twelfth century. It was the Augustinian friars of Bridlington who later founded the Church of St Oswald. Construction was completed in 1230. The Parish Church of St Oswald, Filey, is a large church, leading many to suggest that its role was somewhat greater than that of a simple parish church. It is often referred to as being 'a cathedral in miniature'.

St Oswald's follows a typical cruciform style, having been built during the transitional period between Norman and Early English styles, and dates to somewhere between 1180 and 1230. The church has six bays in the nave, with the chancel being lower than the rest of the church, having a descent of two steps down into it.

Being built during a transitional period of architectural styles, there are aspects of the church that follow a Norman or Romanesque style of architecture but there is also evidence of Early English influence too. The original plan had been to build the tower at the west end of the church, but during the building it was discovered that there was a degree of subsidence at the west end and that the supporting pillars were not truly in the perpendicular plane, so the decision was taken to abort that element of the plan and build a central tower.

A sundial, originally affixed to the church, was placed directly above the priests' door. The sundial had a Greek motto, '*Nyx Epetai*', which roughly translated

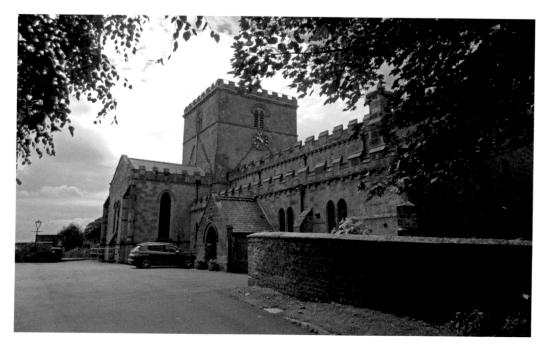

*Above*: Parish Church of St Oswald, Filey.

*Right*: Chancel and east window.

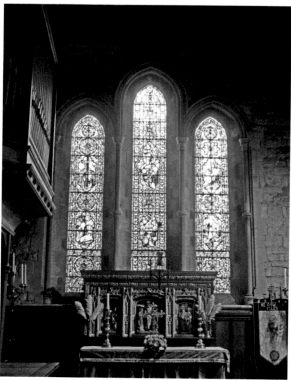

means 'the night cometh'. The inscription is unusual in that the vast majority of inscriptions of this kind are in Latin rather than Greek. Unfortunately, the sundial was stolen in the early 2000s.

On one of her many visits to the Yorkshire coast, Charlotte Brontë is reported to have passed a comment relating to St Oswald's incumbent reverend, Revd Thomas Norfolk Jackson: 'Reverend Jackson is a well-meaning, but an utterly inactive clergyman ... and the Methodists flourish.'

Between May 1885 and August 1866 William Swinden Barber, an architect working from Halifax and Brighouse, designed and supervised the renovations at St Oswald's following the earlier restoration, which had been carried out in 1840. When Barber had completed his work, the newly refurbished church was re-dedicated by the Archbishop of York in August 1886.

After a disastrous fire in 1908, it became necessary to partially rebuild the church's roof. Also, the church organ, which had been built by James Jepson Binns of Leeds, was destroyed and had to be replaced. The replacement organ, which has recently been restored, was built on the side of the chancel.

Later in the nineteenth century St Oswald's vicar, Revd A. N. Cooper, for some reason took it upon himself to walk to London – a distance in excess of 200 miles

Looking towards the chancel.

*Right*: Memorial to a boy bishop who died in his year of office.

*Below*: Three-seat sedilia.

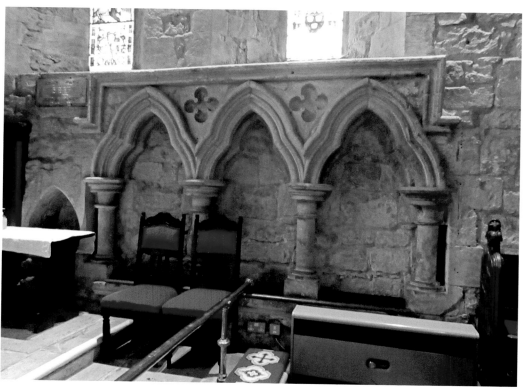

from his parish. Following this sojourn, he was then emboldened to walk to Rome.

A pre-Reformation altar was discovered in the stone floor at the beginning of the twentieth century. The altar, found at the centre of the church, has a small cross at each of the four corners representing the wounds on Christ's body that were made by the nails and the spear and the crown of thorns at the Crucifixion. The altar is now located at the back of the church.

Early in the nineteenth century the church walls were whitewashed, obliterating many of the church's original features. In 1885 the plaster on the walls was removed and many features that had been lost for centuries were revealed once again.

The churchyard at St Oswald's has more than a thousand graves, including twenty-five war graves and the graves of the eight crew members from the fishing vessel *Joan Margaret*, which sank as a result of hitting mines in the Humber Estuary on 20 March 1941.

As recently as 2019 there was a Consistory Court held at York Minster. The reason for the hearing was that a body had been illegally buried in the graveyard in 2018 against the express orders of vicar. However, the body was allowed to remain in the graveyard, as it had been the wish of the deceased to be buried where many of his relatives had been laid to rest.

**Location:** YO14 9ET

## 9. St Peter, Croft-on-Tees

It is thought that there was a church on this site in the twelfth century, as evidenced by a section of the nave's west wall. The original church, however, would in all probability have been aisleless, with the south aisle and the north-east chapel being added sometime during the thirteenth century. A new chancel arch was also added at this time. Significant additions were made in the thirteenth, fourteenth and fifteenth centuries, with further renovations made in the latter part of the nineteenth century. Much of the architecture of the church can best be described as being predominantly of the Decorated style, although the clerestory, which was added during the fifteenth century, follows the Perpendicular style of architecture. There are three windows on either side, each having two trefoiled lights. The small two-story south-west tower was also built at this time and the roof of the chancel, which was originally a high-pitched roof, was lowered and replaced by a nearly flat roof. The porch was built at a later date. The tower is embattled and has belfry windows of two trefoiled lights. The tower is a memorial of the settlement of a quarrel between R. Place and Richard Clervaux.

St Peter's has a redundant ring of three bells. The tenor bell dates from 1672 and the treble, which is inscribed 'Jesus be our speed, TB IR LC TC', dates to 1699. The churchwardens' account book shows that the other bell, founded by Pack & Chapman at the Whitechapel Bell Foundry in 1780, cost £27.

In the chapel and the north door area Anglo-Saxon crosses can be found, indicating that the site was once a location for Anglo-Saxon worship.

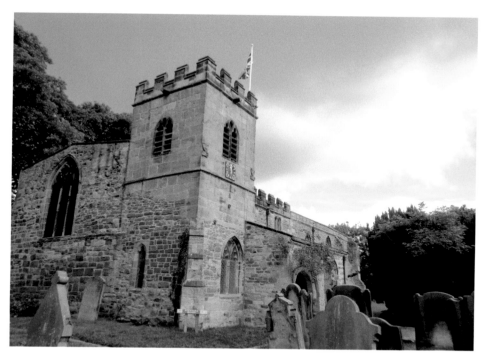

*Above*: Parish Church of St Peter,
Croft-on-Tees.

*Right*: Priests' door.

A number of major building works were commissioned at the beginning of the fourteenth century: the chancel was rebuilt and two western bays were added to the north aisle. Work on the chancel was the direct responsibility of the rector, whereas responsibility for work being carried out on the nave fell to the parishioners.

The church of St Peter, Croft-on-Tees, has a chancel with a north vestry and organ chamber, and a nave with north and south aisles. There is a fourteenth-century priest door to the west of the sedilia.

The large marble tomb of the Milbanke family is in the east bay of the north aisle and dates from the seventeenth century. In the north aisle a carved oak staircase leads to the raised canopied unique pew once occupied by the Milbanke family of Halnaby Hall. The eighteenth-century pew is approached from the west by a wide staircase with twisted balusters. To the east, the aisle is lit by a window of two cinquefoiled lancets, and on the north by three windows. The original stained-glass windows dated from the fourteenth century. The three south windows and the east window of the south aisle are of two lights and, similar those in the north aisle, are more recent insertions.

The two-order continuous arch south doorway dates from the thirteenth century. The porch has a round-headed outer arch which is the full width of the porch. There are stone seats on either side, into which part of a medieval grave slab is built.

The churchwardens' accounts for 1729 show that the cost of taking down and rebuilding the chancel arch amounted to £7 7s (7 guineas).

On the west wall of the north aisle there is a piece of sculpture by the celebrated English sculptor John Bacon. The memorial commemorates Mrs Cornelia Milbanke, who died giving birth to twins in 1795.

The eighteenth-century font has a fluted marble basin set on a square panelled stem.

A small human figure is carved in the wall east of the south doorway. The figure is thought to be a sheela-na-gig, an ancient symbol symbolising life-giving powers and fertility.

The massive table tomb in the Clervaux Chapel commemorates Richard Clervaux. In the north aisle is the seventeenth-century tomb of Sir Mark Milbanke. On the wall close to the entrance of the chapel is the grotesque stone figure of the 'River God'.

There are several items of 'plate' including a cup and cover paten of silver gilt, the gift of Sir Ralph Milbanke (bearing his coat of arms), and a set of two large flagons, one large cup and a paten, which were the gift of Mrs Neale, the widow of a former rector.

In 1868 when Revd Law was rector of St Peter's, the sexton sat in a square box pew that was placed just inside of the church door. The 'Amen Clark' and 'Dog Man' sat to his right – the 'Dog Man' possessed a long pole to scare away unwanted dogs that might have strayed into the church during services.

The hourglass on the wall next to the pulpit was introduced in the reign of Queen Elizabeth I.

St Peter's Church porch.

Near the pulpit is a hagioscope or 'squint window'. The pulpit replaced one of the eighteenth century and was the gift of Revd J. M. Marshall, M. A. Rector and his sisters in 1897 in memory of their mother.

The table tomb of John Todd of Halnaby Hall is in the churchyard. John Todd was buried in 1854.

**Location:** DL2 2SF

## 10. HOLY TRINITY, MICKLEGATE, YORK

There has been a church on this site even before the time of the Norman Conquest. Holy Trinity was originally founded during Anglo-Saxon times, possibly sometime in the seventh century, as a house of secular canons. It was known then as Christ Church.

In 1089, Ralph Paynel, the Norman landowner and Sheriff of Yorkshire, established a Benedictine monastery near to Micklegate.

The church was rebuilt by a community of French monks, and from thenceforth the order became universally known as the 'Alien' Benedictines. The priory,

dedicated to the Holy Trinity, was under the care of the Benedictine Abbey of Marmoutier. There is some conjecture that the church became a 'double church', with one half, Holy Trinity, providing a place of worship for the monastic community, whereas the other half was dedicated to St Nicholas and provided religious services to the lay community of the parish, but this is not a universally held view.

There was a fire in 1137 and the church was completely destroyed and had to be rebuilt. The nave dates from time, with the side aisles being added in the thirteenth century.

A new stone belfry tower was built by parishioners of St Nicholas above the chapel in 1453, indicating strong lay involvement throughout the medieval period. Wealthy merchant parishioners had also founded chantries in the church, such as John de Esshton in 1384 and Thomas Nelson in 1474.

Following the Dissolution of the Monasteries by Henry VIII the priory was closed in 1538, and the monastic church became the new parish church. The church had originally been built with a crossing and a central tower, but in 1551 the chancel was badly damaged when the tower collapsed during a storm. This resulted in the chancel of the former priory church having to be demolished. The stone from the tower was used to repair the city walls and the Ouse Bridge, both of which had suffered during the storm. The nave was rebuilt on a smaller scale.

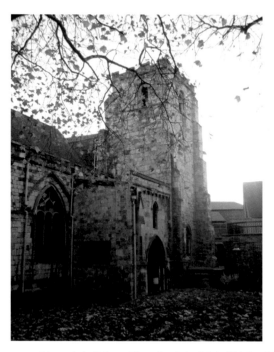 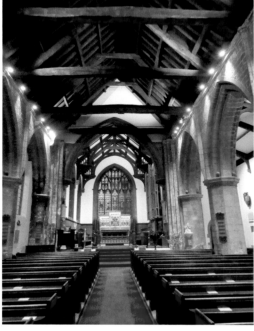

*Above left*: Priory Church of the Holy Trinity, Micklegate, York.

*Above right*: Looking towards the sanctuary.

Towards the end of the nineteenth century the ravages of time were all too obvious, and it became necessary for the church to undergo a major restoration. J. B. and W. Atkinson of York directed the restoration, which took place between 1850 and 1851. The work included rebuilding the south aisle, and re-pewing the whole of the body of the church. The chancel was also rebuilt on the site of the central tower, and the north aisle was demolished.

Between 1886 and 1887 the chancel and vestry were rebuilt under the direction of Fisher and Hepper. Also, a new organ chamber was added. Further restoration took place between 1902 and 1905 when the west front of the church was reconstructed under the direction of the English ecclesiastical architect Charles Hodgson Fowler.

For parishioners who lived at some distance from Holy Trinity, two chapels of ease were built: St James on the Mount and St Helen in Dringhouses.

The church was united with St John's Church, Micklegate, in 1934 and later, in 1953, with St Martin-cum-Gregory, Micklegate.

The earliest surviving stained glass, dating to 1850, is in the north chancel and is by John Joseph Barnett of York. The glass in the north nave, which dates to 1877, is attributed to another York-based stained-glass manufacturer, John Ward Knowles.

The west window, which was inserted in 1904, is by Charles Eamer Kempe and depicts St Benedict, St James, St Martin and St Thomas, all of whose altars were to be found in the former Benedictine priory church.

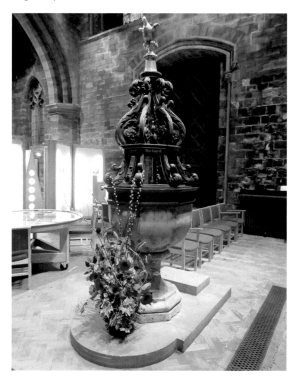

Ornate font.

Replica stocks in the priory grounds.

The chapel of St Nicholas and the font are at the west end of the church. It is thought that the font was brought from St Saviour's Church. The wooden font cover dates to 1717. The chapel has rough stone walls with a modern stone altar, above which is a small lancet window by Charles Eamer Kempe. The window, inserted in 1905, depicts St Nicholas resurrecting three children who had been drowned in a vat of brine by an evil butcher.

The east window is another window attributed to Kempe and is thought to be one of his last works before his death on 29 April 1907. The window shows Christ on the cross and includes a number of images of saints and clerics who have associations with York.

Another one of the stained-glass windows in St Nicholas' Chapel, which was added as recently as 1953, is the result of collaboration between the English ecclesiastical architect George Gaze Pace and Harry James Stammers, a leading stained-glass designer.

Dating from 1906, the organ was built and installed by Norman and Beard, the pipe organ manufacturers based in Norwich.

Until they were recently restored, the two bells at Holy Trinity Church had not chimed since 1984. Both bells were originally cast in York, the larger one towards the end of the fourteenth century and the smaller one in 1731. The earlier bell

bears the Latin inscription '*Johannus Potter me fecit*' ('John Potter made me'). The smaller bell was cast in the foundry of Samuel Smith I. When restoration had been completed, the bells were re-hung utilising the original oak framework; the oak framework itself is thought to date from the building of the church tower in 1453.

A number of saints traditionally associated with the north of England are depicted on the gilded reredos: Paulinus of York, Wilfrid of Hexham, John of Beverley, Cuthbert, Aidan and Hilda.

A modern carving of the Holy Trinity can be seen on a pillar near to the chancel arch. The carving depicts God the Father holding the cross that bears the crucified Christ. The Holy Spirit is portrayed as a dove flying from God's mouth.

On the north wall of the nave there is a memorial that was erected by Dorothy Katharine Bewis in honour of her parents, Captain Edwyn Walker and Elizabeth, and her four brothers, three of whom – Captain Oswald B. Walker, Major Wilfrid B. Walker and Captain Roger B. Walker MC – were all killed during the First World War, and Edwyn G. Walker who was killed in a point-to-point race in 1910. At the back of the south aisle there is a memorial to the dead of the First World War.

Wooden stocks, which had stood in the church grounds since the sixteenth century, were used for the punishment of minor crimes and nuisances until the law changed in 1858. The original stocks are now displayed in the church and replica stocks were set up in the church grounds in 2006.

**Location:** YO1 6LE

## 11. ST ANDREW, EAST HESLERTON

The Church of St Andrew is the third church to be built on this site; the first is thought to have dated from the Norman period. Built between 1873 and 1877, the church at East Heslerton replaced an earlier and more modest nineteenth-century church which occupied the same site. Designed by the eminent Victorian Gothic Revivalist architect George Edmund Street, the building was the last of six new churches commissioned by Sir Tatton Sykes II, 5th Baronet of Sledmere.

Built of Aislaby sandstone, the church, which predominantly follows the Gothic transitional style of architecture, has a western narthex porch, a five-bay nave with a plain wagon roof, a chancel with an apse, a baptistry and a vestry. The tower and vestry are on the north side, whereas the baptistery is on the south side. The octagonal broached spire rises to a height of 105 feet.

In 1873 Sir Tatton Sykes of Sledmere House, who had renovated a number of churches in the area, commissioned George Edmund Street to redesign and rebuild St Andrew's. The work was completed in 1877. Street had already either restored or built a number of churches for Sir Tatton, but St Andrew's was the first church that he was responsible for the overall design and the furnishings.

Just above the level of the belfry windows, between the louvred openings, are four statues which represent the four fathers of the Latin Church – St Ambrose, St Augustine, St Gregory and St Jerome. The statues, which were carved by James Frank Redfern, were originally intended for the north porch of Bristol Cathedral, but shortly after their installation in 1876 the dean of the cathedral deemed that

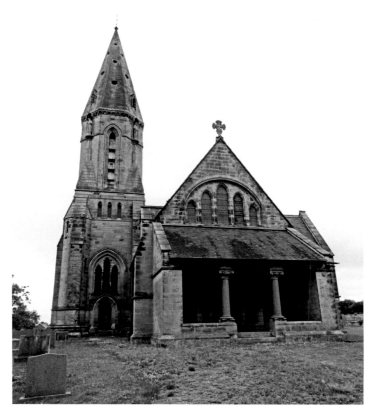

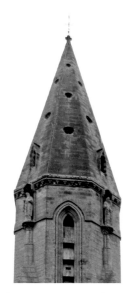

*Above*: Four statues that represent the four fathers of the Latin Church.

*Left*: Parish Church of St Andrew, East Heslerton.

that were too papist and ordered them to be removed. The dean's action caused some controversy in the city and also delayed the finishing of the cathedral. James Redfern died later that year. Fortunately for the church at East Heslerton, George Street, who had been working on a new nave at the cathedral since 1868, was able to buy the statues at a reduced price and have them installed at St Andrew's, as both he and Sir Tatton favoured high church imagery. In 1882 Sir Tatton's wife, Jessica, converted to Roman Catholicism.

In his detailed specifications, Street stipulated that all of the stained glass in the church should be manufactured and installed by the London firm of Clayton and Bell. The windows follow a sequence, with the Passion, Resurrection and Ascension in the east of the church. Other windows depict the Three Marys at the Tomb, the Resurrection of Christ, the Entombment and *noli me tangere* ('do not touch me'). The group of five lancets in the west wall show the Nativity with the visit of magi and shepherds. The baptistery has a roundel showing Christ in Glory. Three national saints are shown on the south side of the nave, with windows depicting three archangels on the north side. The Jesse window is one of two windows that can be seen under the tower. A monogram, 'TS', together with the date of 1877, can be seen in many of the windows, presumably indicating that Sir Tatton Sykes himself played some part in the design of the windows.

*Above*: The five-light west window by Clayton and Bell, depicting the Nativity.

*Right*: The octagonal font carved from Caen stone.

The octagonal font has lobed sides and is carved from Caen stone. Similar to the font, the pulpit is made of Caen stone and has Derbyshire shell marble decorated with an inlayed floriated cross.

The bronze roll of honour lists the nineteen men from East Heslerton who fought in the First World War, seventeen of whom returned but two lost their lives in battle.

Directly above the vestry door there is a carved frieze of the Annunciation. The carving has depictions of the Virgin Mary and the Archangel Gabriel.

The painted polyptych behind the altar, the reredos, are representations of the *Te Deum Laudamus*.

St Andrew's has a ring of three bells, all of which were cast at the foundry of John Taylor & Co. of Loughborough between 1876 and 1877.

The maker and date of manufacture of the organ at St Andrew's is unknown, although it is thought that it was made by J. W. Walker & Sons Ltd sometime in the 1870s. What is known, however, is that the organ was transferred to St Andrew's in 1937 from a church in York.

The two stone seats in the sanctuary, the sedilia, were specifically for the use of the officiating clergy.

The painted polyptych reredos behind the altar.

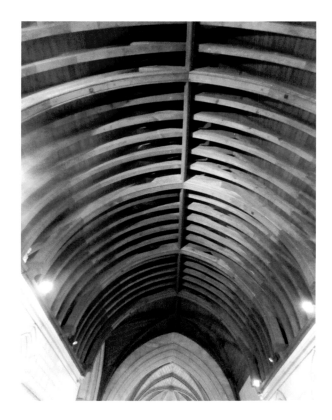

The plain wagon roof.

The floor of the nave is boarded in oak and the pews are made from oak. Many of the Victorian floor tiles in the church depict the three lions, often viewed as being symbolic of patriotism.

George Edmund Street designed the wrought-iron chancel gates, which were manufactured and installed by Potter & Sons of Hull. Both the sandstone lychgate and the wall around the churchyard were designed by Street, as was the cross that stands in the churchyard.

**Location:** YO17 8RN

## 12. St John the Baptist, Knaresborough

At the time of Domesday, the lands in and around the vicinity of Knaresborough formed part of the Conqueror's demesnes and were given by him to Serlo de Burgh, baron of Tonsburg in Normandy, who had accompanied him from France.

The first reference to there being a church at Knaresborough is noted in 1114 in the records of Nostell Priory. The record states that King Henry I granted the 'Church at Cnaresburgh' to the canons at Nostell. At that time the ancient church was dedicated to the Blessed Virgin and continued to retain that name until the Protestant reforms of the sixteenth century, when it changed to become the Church of St John the Baptist.

The cruciform church primarily follows the Perpendicular style of architecture and has a chancel, a nave of four bays, north and south chantry chapels, transepts, aisles, a south porch and a central tower and spire.

At the beginning of the fourteenth century the church was in a dilapidated state as a direct result of an earlier raid by Scots invaders in 1318, who set fire to it. In 1328, shortly after their wedding, King Edward III and Queen Philippa of Hainault were visiting the town and couldn't fail to notice the poor state of repair of the church. Queen Philippa felt that it should be restored and King Edward endeavoured to ensure that this happened. Throughout the period of restoration, Queen Philippa took an active interest in the progress of the works, especially the redesigning of St Edmund's Chapel. When the queen died in 1369, her name had become synonymous with that of the church and, from thereon in, colloquially, the church became known as the Queen's Church.

Revd Thomas Collins had eight bells installed at St John's in 1774. The bells were cast by Pack & Chapman at Whitechapel at a cost of £462 3s. There was an additional charge of £82 11s 5d, which covered the cost of carriage from London.

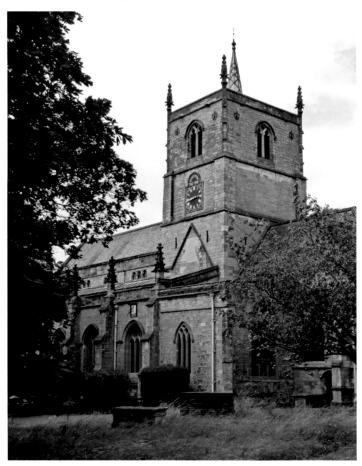

Parish Church of
St John the Baptist,
Knaresborough.

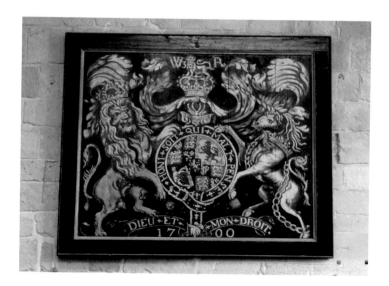

Royal coat of arms
of William III,
dating to 1700.

However, part of the cost, £226 10s, was defrayed when four of the twelve bells of
the now dissolved Trinitarian Priory at Knaresborough were melted down and the
molten metal used in the founding of new bells. The two treble bells were recast
by Taylor's of Loughborough in 1925, and the remaining six bells were re-tuned.
All eight bells retained their original inscriptions.

The three-train, flat-bed clock was manufactured by Potts of Leeds and dates to
1884. The face has St Paul's phrase 'redeeming the time' upon it.

The base of the tower dates from the twelfth century, with the upper stages
dating from the fourteenth or fifteenth centuries.

On the north side of the chancel there is the Slingsby Chapel with many
monuments to the Slingsby family, baronets of Scriven. The family's associations
with Knaresborough dates back to the early fourteenth century. In the centre of
the chapel there is an altar tomb of Caen stone with effigies of Francis de Slingsby,
who reclines in full armour, and his wife, Mary. The sculpting of the tomb is
attributed to Thomas Brown, whose fee for the commission was reputedly £13.
On the south side there is a memorial to Thomas Slingsby and also a standing
figure of Sir William de Slingsby, Kt Commissary of the Fleet.

The north side has an effigy of Sir Henry de Slingsby, and on the floor there is
a slab of black marble with a dedication to Sir Henry de Slingsby. There are also
monuments to Dorothy, wife of Sir Thomas Slingsby Bart, and a marble effigy by
Boehm of a recumbent Sir Charles Slingsby of Scriven, 10th (and last) Baronet.
Sir Charles died in a ferryboat accident on the River Ure on 4 February 1869.
Many of the effigies in the Slingsby Chapel are thought to have been sculpted by
the British sculptor Epiphanius Evesham.

There is a royal coat of arms to William III, which dates to 1700. The
Perpendicular font has a Jacobean carved oak cover.

During the nineteenth century major restoration work was carried out on the
church, including creating a slate roof and removing the public galleries. In 1872

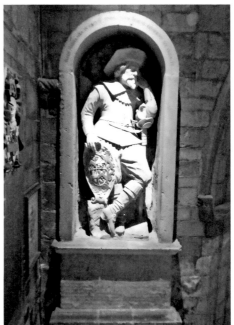

*Above left*: Sixteenth-century south porch entrance.

*Above right*: Standing figure of Sir William de Slingsby.

the Collins family presented St John's with a reredos, during which time the church was being refurbished and completely re-seated. Then, in 1875, the Roundell Chapel on the south side of the chancel was restored. At that time a stained-glass window was inserted by William Roundell Esq. in memory of his parents and siblings. There are also windows commemorating the Powell, Beaumont and Shaw families, and a window commemorating a former vicar of the parish, Revd James Fawcett. The west window was inserted as a memorial to Sir Charles Slingsby Bart, whereas the window at the east end is in memory of Hugh G. Christian Esq. of Fysche Hall. Many of the stained-glass windows in the church were designed and manufactured by the William Morris studio.

In 1894 James Jepson Binns of Bramley, Leeds, installed the church's third organ, a three-manual pipe organ that cost £1,012. The organ was later rebuilt by Harris of Birmingham; more recently, J. M. Spink of Wakefield carried out major repairs on it, which included replacing soundboards and installing a new swell engine.

Knaresborough has the distinction of being the first parish in the country where Maundy money was distributed. The money was first distributed by King John on 15 April 1210, and the ceremony has been continued on Maundy Thursday ever since.

The churchyard was landscaped in 1973.

**Location:** HG5 9AE

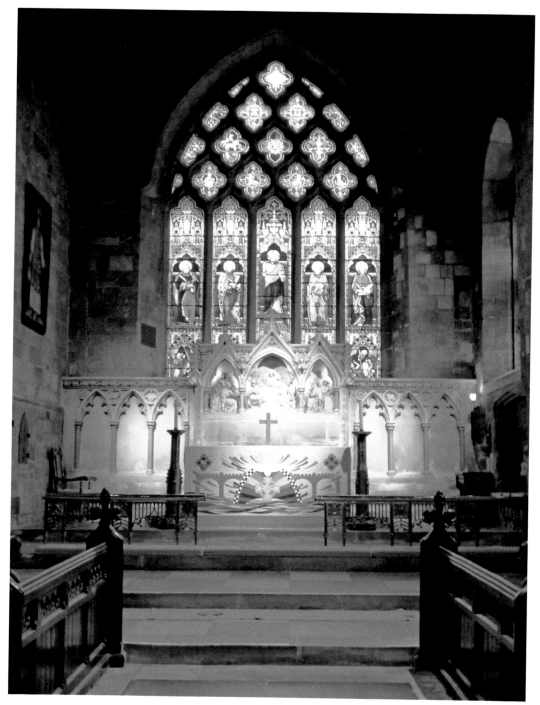

The east end window is in memory of Hugh G. Christian Esq. of Fysche Hall.

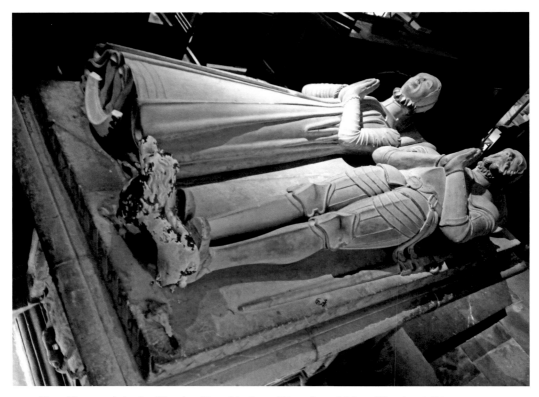

The oldest tomb in the Slingsby Chapel is that of Francis and Mary Slingsby, 1601.

## 13. SELBY ABBEY, SELBY

The first church, which Benedict built near to the Ouse, was probably of wooden construction. Then, in 1069, Viscount Hugh, representing William the Conqueror, erected the Abbey of Selby following the issuing of a royal charter in the same year.

The abbey, which is dedicated to St Germain, Our Lord and St Mary, contains the St Germain window in the north transept, which depicts forty-six scenes from the life of the saint. The window contained exquisite medieval glass and, in 1631, a substantial amount of money was offered in order to buy and transfer the window to Continental Europe. The offer was rejected. Unfortunately, during the Civil War and the religious period known as the Commonwealth, the glass was destroyed and replaced with plain glass. However, in 1914, Miss Standering had the present glass inserted in honour of her parents. The Germanus Window is the only one of its kind in the world.

St Germain, a French man, is generally acknowledged as being the patron saint of the abbey, although the abbey is actually dedicated to Our Lord, the Blessed Virgin Mary and St Germain. Following an abstemious life, Germain rose to become Bishop of Auxerre. Throughout his ministry he travelled widely in

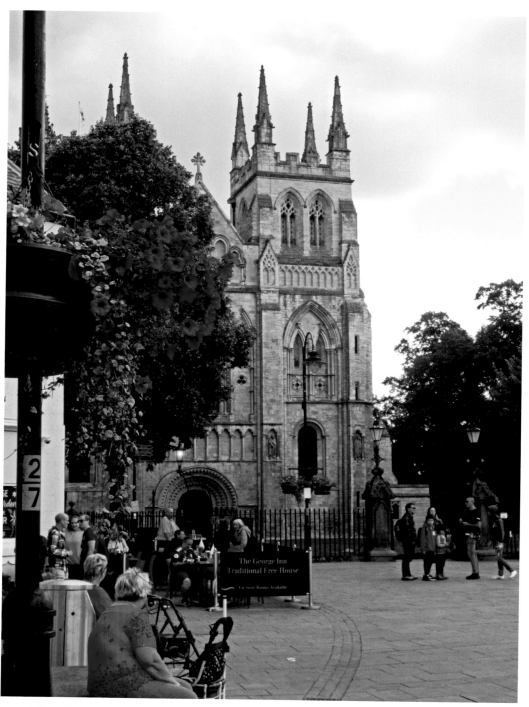

Selby Abbey, at the heart of the community.

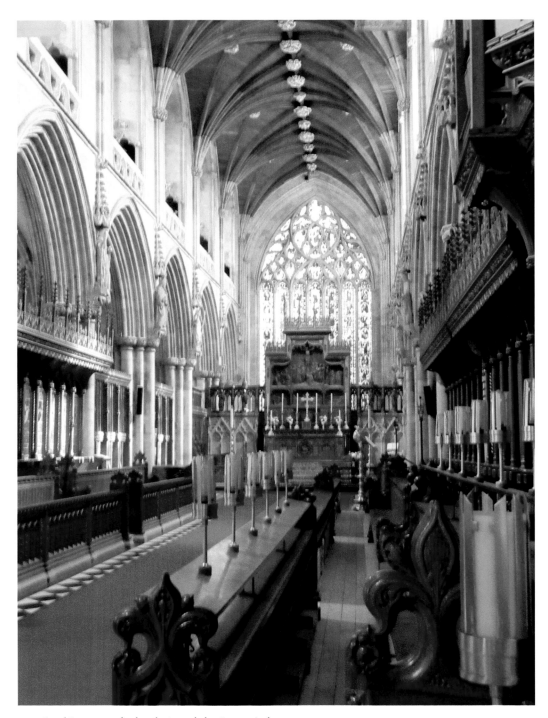

Looking towards the choir and the Jesse window.

England and Wales, converting many people to his faith. Then, early in the fifth century, when border villages in Wales were being pillaged by pagan Picts and Saxons, Germain assembled a body of men and took them to an area where there was known to be a distinct echo. When the Picts and Scots arrived on the scene, the Britons shouted 'Alleluia! Praise the Lord!' The deafening and resounding noise around the valley so startled the invaders that they turned tail and ran away. Germain was credited with the bloodless victory, which became known as the 'Alleluia Victory'. In the years that followed many churches were dedicated in his name, perhaps the most famous being the abbey at Selby. Germain died in 448, at Ravenna, Italy.

On 31 May 1256, Pope Alexander IV bestowed the abbey with the grant of a mitre, giving the abbey the status of a 'Mitred Abbey' – in effect meaning that the mitred abbot was exempt from any episcopal visitation or control. However, when Archbishop Walter Giffard visited the monastery in 1275, he found that many of the monks and the abbot himself were transgressing the Rule of St Benedict. Archbishop William de Wickwane made similar observations when he visited the abbey in 1279. The situation had not improved when Archbishop William Greenfield visited the abbey in 1306.

The quire was rebuilt in the early part of the fourteenth century, but shortly after its completion fire damaged the chapter house, dormitory, treasury and some of the other abbey buildings. Funds were raised in order to carry out remedial work on the damaged buildings. During this time, services were conducted by

Pulpit at Selby Abbey.

*Left*: The fifteenth-century wooden font cover that survived the great fire of 1906.

*Opposite*: The St Germain window in the north transept.

the monks at Brayton, which had become part of the abbey estate. As reparations were being made, windows were inserted in the south aisle of the nave.

Perpendicular windows in the north transept and at the west end of the nave were added in the fifteenth century and later, in 1465, the Lathom Chapel, dedicated to St Catherine, was added.

Similar to many churches in the region, the abbey suffered from subsidence and in 1690 the central tower completely collapsed, destroying the south transept.

Between 1871 and 1873 Sir George Gilbert Scott restored much of the church, including the nave. Then, between 1889 and 1890, his son John Oldrid Scott, restored the choir. The early part of the twentieth century saw the restoration of the tower.

On 26 September 1912, the south transept was re-consecrated, having been rebuilt through the generosity of the late Mr William Liversedge.

In 1935 the height of the towers at the front was raised under the direction the architect Charles Marriott Oldrid Scott, son of John Oldrid Scott.

There was a major restoration of the abbey in 2002, which included restoration of the 'Washington Window', the cost of which was met by British American Tobacco.

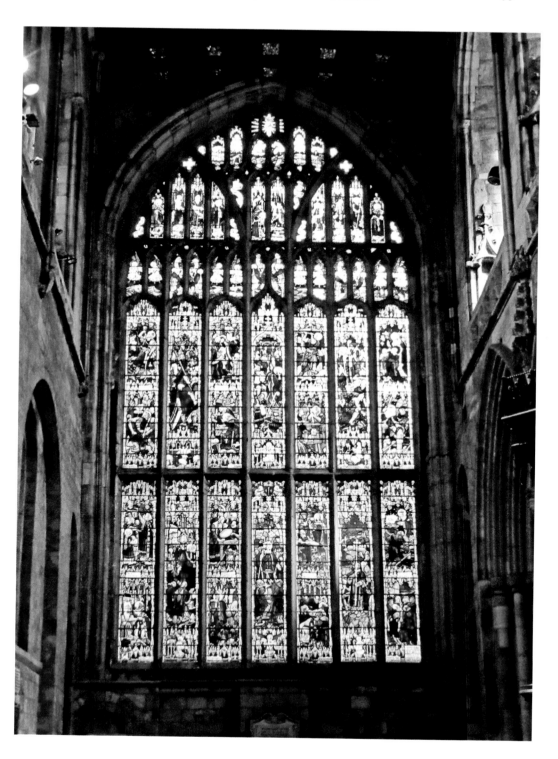

It is known that four bells were hung in the abbey in 1614, with an additional bell being hung some five years later in 1619. However, catastrophe befell the abbey in 1690 when the central tower of the abbey collapsed, destroying the bells. In 1710 the bells were re-cast using the metal from the old bells. A treble was added twenty-three years later, making a ring of six. In 1863 another two bells were added, completing the octave.

The bells came crashing to the ground during the great fire of 1906. Then, in 1908, following a decision to create a ring of ten bells, John Taylor & Co. (Bellfounders) Ltd were awarded the contract to design, cast and fit the new bells. The abbey participated in the 'Ringing in the Millennium' project, adding new bells which were also cast and hung by John Taylor & Co.

In 1825 an organ had been installed by Renn and Boston in a gallery on the east side of the quire screen wall. The organ was rebuilt on a number of occasions by several different contractors. Then, in 1868 the organ was rebuilt and moved to a bay in the quire. This organ was rebuilt in 1891 by James Jepson Binns of Bramley and moved again to the north side of the quire. The organ was rebuilt in 1906 by John Compton. Sometime during the installation of a new kinetic gas engine in October 1906, which was being installed to provide power to the rebuilt organ, flames were seen to be coming from the organ chamber. At the time it was reported that the new organ equipment and the company installing the equipment were to blame for the catastrophe, but these reports were later proved to be incorrect. The fire, which quickly engulfed much of the immediate area, completely destroyed the organ, the belfry, the roof of the quire and the church's peal of bells. Fortunately, because of the fire brigade's prompt action, the fourteenth-century stained glass in the east window was saved.

William Hill & Son was commissioned to build a new organ. The instrument was designed by John Oldrid Scott, who also supervised the rebuilding of the abbey, which was rebuilt and reopened in 1909.

The organ was restored in 1950 by Hill, Norman and Beard, with further additions made in 1975 by John T. Jackson. Between 2014 and 2016 the organ was restored by Geoffrey Coffin and Principal Pipe Organs of York. However, at the beginning of the twenty-first century, it was all too evident that the organ was in urgent need of a major overhaul. In 2012 an appeal was launched to raise the funds necessary for the restoration.

In 1969 Selby Abbey had the honour of being the first parish church in the realm of Queen Elizabeth II to hold the annual service for the distribution of the Royal Maundy.

**Location:** YO8 4PU

## 14. HOLY TRINITY, WENSLEY

The thirteenth-century Church of Holy Trinity, Wensley, was built in 1245, replacing an earlier Norman structure. However, it is thought that the Norman church was itself built on the foundations of an even earlier Anglo-Saxon building that stood on the same site. A number of alterations were made during the fourteenth and fifteenth centuries.

Throughout the church there are many monuments to the Scrope family of Castle Bolton, who played a prominent part in its history from the thirteenth century onwards. In 1614 a Purbeck marble monument to two members of the family was erected in the north aisle. The carved seventeenth-century Scrope family pew is in the nave. Prominently featured in the pew is a carved parclose screen from the early sixteenth century, which, it is thought, was brought over from Easby Abbey after it had been abandoned and left to fall into ruins following Henry VIII's Dissolution of the Monasteries. The pew has eighteen elaborately carved panels.

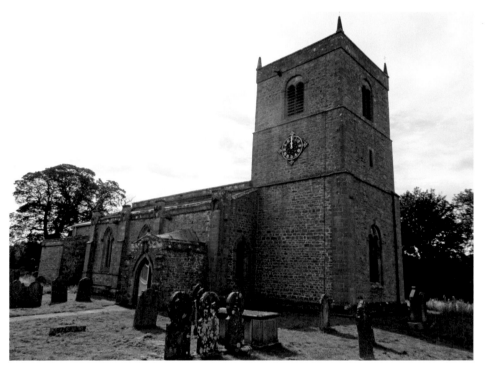

*Above*: Parish Church of Holy Trinity, Wensley.

*Right*: Church clock on the north face of the tower. It was placed there in memory of Revd Thomas Orde-Powlett, rector of the parish from 1850 to 1894.

Further changes were made in the eighteenth century when box pews were installed in the nave to augment the seventeenth-century benches. The triple-decker pulpit, which had been installed in 1760 at a cost in excess of £12, was also converted to a double-decker pulpit at the same time. Many of the other decorated pews, which date to 1527, were carved by a school of craftsmen collectively known as the 'Ripon Carvers'.

Much of the south chancel remains unaltered, but the nave, aisles and north porch were remodelled sometime during the fourteenth century. The following century saw the addition of the south porch and the raising of the aisle roofs.

There are a number of fragments of Anglo-Saxon stones built into the church walls. The church has a chancel with a north vestry, a nave with north and south aisles, and north and south porches. There is also a three-stage west tower, the lowest stage having buttresses and a two-light west window. The second stage of the tower has single-light windows on the west and south faces, a door on the east side and a clock on the north face. The clock is dated 1899 and was placed there in memory of Revd Thomas Orde-Powlett, rector of the parish from 1850 to 1894. The clock was made by W. Potts and Son of Leeds. The third stage of the tower has two-light bell openings.

There is a two-light west window in the south aisle. The sundial above the opening of the fifteenth century gabled south porch dates from 1846. The earlier north porch dates from the fourteenth century and has coats of arms above the

*Above left*: Decorated pews, carved by school of craftsmen known as the Ripon Carvers.

*Above right*: Double-decker pulpit – originally built as a triple-decker pulpit.

doorway. Holy Trinity has a five-light east window. The north side vestry has two storeys with a two-light window on each storey.

The tower arch, the chancel arch and the three-bay arcade, all date from the fourteenth century. There are two inscribed eighth-century cross-slabs in the church and a number of other fragments from eighth-century slabs. There is a wheel-head cross and a cross shaft embedded into the walls of the south porch.

The north and south porches, and the north vestry with priest's lodging on the level above, were built in the fifteenth century, with the tower and the western ends of the aisles being rebuilt sometime in the eighteenth century.

A three-manual pipe organ was installed on 19 April 1883. The organ was built by Isaac Abbott of Leeds in memory of Letitia, Baroness Bolton and opened on 19 April 1883. The organ was later restored by Wood Wordsworth & Co. Ltd, organ builders of Leeds.

In the northern aisle there is a wooden-panelled cupboard which, it is believed, at one time held the relics of St Agatha. The fifteenth-century cupboard was brought over from Easby Abbey at the time of the Dissolution of the Monasteries. St Agatha was the patron saint of Easby Abbey.

The church has a ring of three bells. Two of the bells were cast at the foundry of Samuel Smith in 1725, with the third bell being cast by Charles and George Mears of the Whitechapel Bell Foundry in 1847.

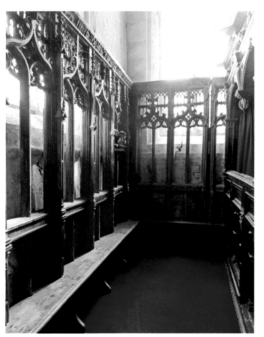 

*Above left*: Scrope family pew.

*Above right*: The fifteenth-century cupboard was brought over from Easby Abbey at the time of the Dissolution of the Monasteries.

There are two outstanding brasses in the sanctuary, the first commemorating a former rector of the parish, Sir Simon de Wensley, who died in 1394, and the second commemorating Rector Oswald Dykes, who died in 1607.

A major programme of restoration was embarked upon in 1927, when the whitewash on the church walls was removed and the roof was renewed. It was during this restoration that fragments of medieval wall paintings, including a mural of the Three Living and the Three Dead, were revealed on the north wall of the nave. There are many different versions of this story, but whichever tale is told, it is always simple in its brutality: three young hunters – a prince, a duke and a count – are confronted with three dead bodies who present themselves in different states of decomposition. There is then a brief exchange during which the three young people are accused as being prideful, coming from wealthy and powerful families. God had put them in the presence of these three emaciated dead souls as a warning. Each character then speaks to them. In the end, the dead leave the living pale and frightened, drawing the moral: 'Let us lead the life that pleases God; let us beware of going to hell; let us know that death will seize us too, and pray to Our Lady, at the hour of our death, to be close to her son.'

Another of the painted fragments that can still be seen on the south wall of Holy Trinity is a depiction of St Eloi. The story is told that Eloi, who became a French bishop, was proud of his prowess at the forge and often boasted of his skills. One day a traveller came to Eloi's forge and asked if he could use it to re-shoe his horse. Having been given permission to use the forge, the traveller proceeded to twist off the horse's leg, nail the shoe onto the horse's hoof and then replace the leg. Eloi boasted to the stranger that he could use the same approach to shoe a horse. He then removed his horse's leg, nailed on the new shoe, but then found that he couldn't reattach it, and by this time the horse was near to death. The farrier pleaded with the stranger to help him out of his predicament. Before too long the leg was restored, but the farrier could see no sign of the stranger. Eloi realised that he had witnessed Jesus performing a miracle and spent the rest of his life devoted to the Church. He was made the patron saint of farriers and blacksmiths.

The Bishop of Knaresborough, the Right Revd Lucius Smith, reopened the church on 25 January 1928. An unusual find was made that year when, under a heap of rubble in the tower, a carved seventeenth-century font cover was discovered. The wooden font cover is surmounted by a pineapple finial. The lead-lined font, dating to 1662, also had carved inscriptions of the name of the then rector of the parish and the names of the two churchwardens.

**Location:** DL8 4HX

## 15. St Oswald, Lythe

The Domesday Book makes reference to the manor of Lythe, which was held by Nele Fossard, but there is no mention of a church being there. However, during the pontificate of Pope Alexander III, between 1159 and 1181, records show that Nele's son, Robert Fossard, granted the church of Lythe to the Augustinian monks at Nostell Priory, which was subsequently named after their dedicated saint, the

martyred St Oswald. The Christian King Oswald of Northumbria was killed by the pagan King Penda of Mercia at the Battle of Maserfield on 5 August 642. There is a special memorial board on the west wall of the church, just behind the font, which shows that in 1154 the priest of Lythe was Robert. In all probability, this citation refers to Robert Fossard, Lord of Mulgrave, who was born in 1138, son of Robert Fossard. The list also includes the name of John Fisher, who was to become Bishop of Rochester, and sometime later a cardinal. As a Catholic, John Fisher was executed for treason in 1535.

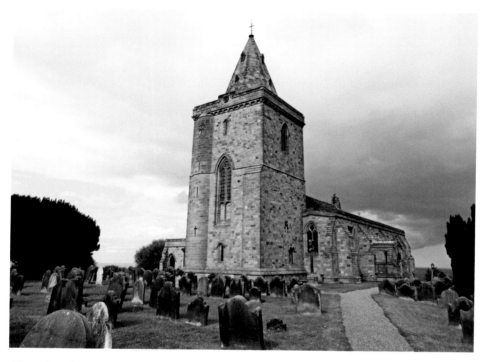

*Above*: Parish Church of St Oswald, Lythe.

*Right*: Anglo-Scandinavian carved funeral stones dating from the ninth or tenth centuries, suggesting that the site was an important Viking burial ground.

There has been a church on this site since the thirteenth century, although following rebuilding and refurbishment at the beginning of the twentieth century, the present building is now very different from the former church.

The parish church of St Oswald, Lythe, has a chancel, a vestry on the north side and a chapel on the south side, with the nave having both north and south aisles. The nave has five bays, with alternating circular and octagonal pillars with pointed arches. The church has a south porch, over which is a sundial. There is a square west tower, which is surmounted by a short stone spire. With the church being located so close to the shoreline, the Norman tower was fitted with a spire. Its primary function was to act as a waymark and coast-marker for ships sailing along that dangerous part of the north-eastern coast.

In his will, Thomas Artas, the then rector of Lythe parish, bequeathed £6 13s 4d for a bell tower to be built for the reception of three bells. The tower was erected in 1796. The tower now houses two bells, both of which have inscriptions; the first bell bears the inscription 'Gloria in Altissimis Deo, 1682', whereas the second bell has the inscription 'Sanctus Oswel Deo'.

In 1819 the south side of the church and the upper part of the north side, together with the porch, were rebuilt.

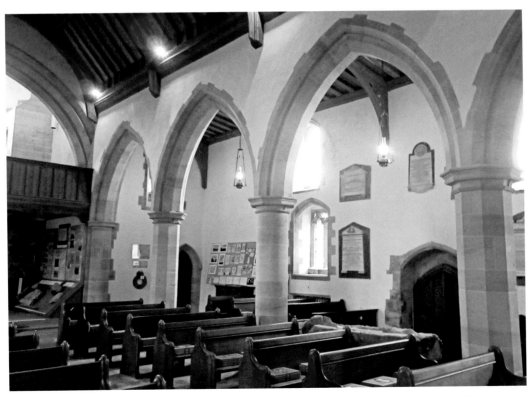

The five-bay north aisle, with alternating circular and octagonal pillars and pointed arches.

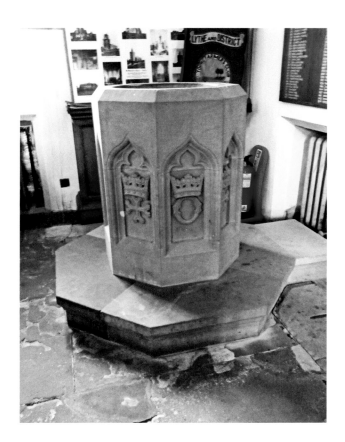

The memorial board, just behind the font, shows that in 1154 the priest of Lythe was named Robert.

Between 1910 and 1911 the Gothic Revivalist architect Sir Walter John Tapper was commissioned to rebuild the church. During the restoration a large number of Anglo-Scandinavian carved stones, thought to be funeral monuments, were found to have been built into the church walls, most notably in the construction of the tower which had been completely rebuilt in 1769. The collection, which dates mainly from the ninth or tenth centuries, includes portions of cross heads and shafts and hogback stones, which would suggest that the site was an important Viking burial ground. Two of the stones date from the eighth century, giving rise to speculation that there could have been a stone church on the site even before the Vikings arrived.

The early twentieth-century restoration was financed by Revd Constantine Charles Henry Phipps, the 3rd Marquess of Normanby. A number of other benefactors gave donations to the rebuilding. The church was reopened on Monday 9 October 1911.

A number of changes had been made before Tapper's restoration. It had become necessary to reinforce the walls with buttresses. Also, the top of the tower had been removed in 1786 'for fear of it falling down upon the church'.

There is now a permanent exhibition, 'The Stones of St Oswald's', at the west end of the church.

The primary function of the spire was to act as a waymark and coast marker for ships sailing along that dangerous part of the north-eastern coast.

In 2018 the roof slates were completely replaced for the second time, when the roof tiles which had been put there by Tapper were replaced with newer stones.

The Lady Chapel has a magnificent vaulted roof. There is a depiction of St Oswald in the chapel's east window. The south window is by way of a war memorial which commemorates the Old Boys of Mulgrave Castle School. The stained-glass window above the choir vestry is a rare depiction of Tobias and the Angel.

The church plate includes a cup with a cover dating to 1634. The bowl carries the inscription, 'Belongeing to the Parish of Lythe in Yorkeshier 1635'. There is also an inscription on the bottom of the cover: 'Lythe Church in Yorkeshier 1635'. Also of the same date, the church has a silver-guilt chalice and paten. There are a number of other items from later dates.

The churchyard at St Oswald's has a vast number of graves, some dating from the tenth century. Many of the earlier graves are those of members of the influential Phipps family, who for many years were the owners of Mulgrave Castle and the 16,000-acre Mulgrave estate. In 1994 Oswald Phipps, 4th Marquess of Normanby, was buried here.

On the south-west side of the church there is a memorial to the seventeen men from the village who lost their lives during the First World War. The memorial also commemorates seven unknown sailors who were washed ashore during the same period.

Perhaps one of the most poignant memorials in the churchyard is that to three fishermen, Charles Verburgh, Maurice Vandewalle and John Deretter, all of whom are buried in the churchyard and were members of the crew of the trawler *Jeanne*

of Oostende, Belgium. The trawler ran aground shortly after midnight on the night of 15 February 1932.

In 1887 the churchyard was enlarged at the west end. A lychgate was also built on the south side of the churchyard at the same time.

**Location: YO21 3RW**

## 16. ST MARY THE VIRGIN, HEMINGBROUGH

The Church of St Mary the Virgin, Hemingbrough, is sometimes referred to as Hemingbrough Minster. Before the Norman Conquest the parish was held by Lord Tostig, brother to King Harold Godwinson.

Reference is made to there being a church at Hemingbrough in the Domesday Book; however, every trace of that church has long-since disappeared and only the two easternmost bays on each side of the nave of the Norman church that replaced it still remain.

Hemingbrough was part of William the Conqueror's domains at the time of Domesday. His lands at Brackenholme, together with the manor and the church at Hemingbrough, were given to the Bishop of Durham, and in turn passed to the prior and convent of Durham in 1356. On 26 October 1426, King Henry VI granted a royal licence to the prior and convent of Durham, enabling them to convert the parochial church of Hemingbrough into a college. In 1427 the church assumed collegiate identity, with a provost or warden, three prebendaries or honorary canons, six vicars choral and six clerks. This situation continued until the college was suppressed by Henry VIII in 1534. After the Dissolution, the church's advowson was passed to the Crown and thence, in 1898, to the Archbishop of York. During the intervening period there were many changes made to the fabric of the church.

The present church dates from the beginning of the thirteenth century. The outside follows the Gothic style of architecture, although there are many Norman elements inside, such as the round pillars and round arches that separate the nave and side aisles.

The square tower was built in the thirteenth century, with the 191-foot-high tapering octagonal spire being added sometime between 1416 and 1446. Because of its dangerous condition, the top section of the spire was renewed in 1989; the cost, reputedly, wase in excess of £400,000.

The nave and the south aisle of the chancel have four bays. Both transepts, north and south, have two bays. With so many additions made to the church over the centuries, it is understandable that many different styles of architecture are displayed, the earliest of which is to be seen at the east end of the nave.

The church has a chancel with north vestry, a central tower with spire and transepts, north and south chapels, an aisled and clerestoried nave, and a south porch.

During the Perpendicular period, the transepts, which had originally been built during the earlier re-modelling phase, were altered, a clerestory was added, and five-light windows were inserted in the north and south gables.

St Mary's had four chantries, the first being the Waise chantry, which was founded by Robert de Marisco, who was rector between 1217 and 1258 and

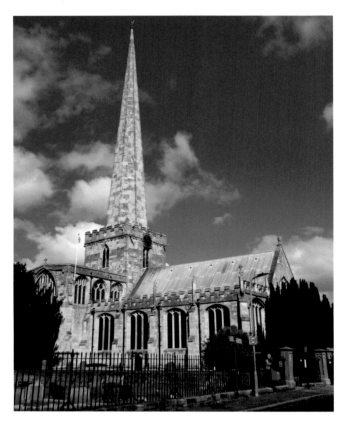

*Left*: Parish Church of St Mary the Virgin, Hemingbrough.

*Below*: Ancient wood carving of unknown origin.

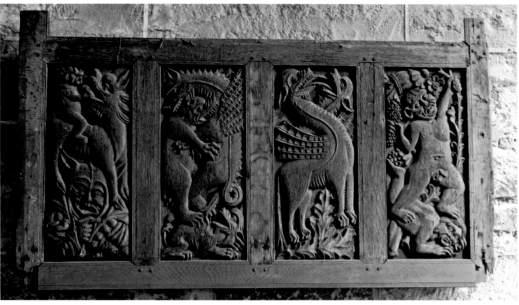

later that year became Dean of Lincoln. The chantry, which was dedicated to St Catherine, was worth £6 13s 4d in 1535. The second chantry, established in 1345 and known as the Cliffe chantry, was founded by the executors of Henry of Cliffe. At the Trinity altar is the Babthorpe chantry, named after Thomas Babthorpe, who, in a will dated 1478, bequeathed a vestment to a chaplain who should celebrate there. The fourth and last chantry, the West chantry, was named after John West by his executors in 1529.

The transepts were used as chapels, with the Babthorpe chantry chapel, between the north transept and the vestry, being built after the deaths of Thomas Babthorpe's father and brother in 1455. The south chapel, which was used as a Lady Chapel, was built sometime after 1513 by Anne Manners of Turnham Hall.

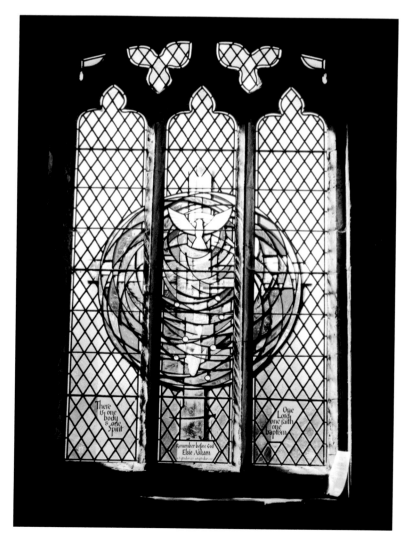

Baptism window.

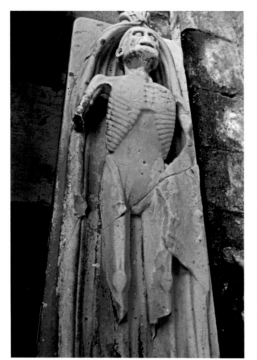

*Above left*: Cadaver with the message 'As I am now, so shall you be'.

*Above right*: Misericord dating from *c.* 1200.

The pews and choir pews have carved ends, some with carved heads or animals. One of the choir pews still retains a misericord; it is reputed to be the oldest in England and dates from the beginning of the thirteenth century. The tub-shaped font at the back of the south aisle dates from 1180. In 1717 the Jacobean pulpit was moved beneath the south aisle.

When repairs to the spire were made in 1762 reference was made to there being a weathercock on the spire. When some restoration work was being carried out on the church roof in 1987, it was thought that, after such sterling service, it was time to replace the ancient weathercock.

In 1552 St Mary's had a total of four bells, but in 1730 the bells were re-cast at the foundry of E. Sellars of York, creating five new bells. A sixth was added in 1907.

Dating from 1617, the church plate includes a silver cup made by Francis Tempest of York. There is also a pewter plate and two flagons, one dating to 1719 and bearing an inscription of the donor's name, John Allison of Lund.

Records show that a new clock for St Mary's was purchased for £40 in 1735, although a discount of 4s 6d was given when the old clock was traded in. In 1776 it was recorded that William Kirlew, the church clerk, was awarded the princely sum of £2 for cleaning the flagons, winding the clock, washing the surplice and

tablecloth, cleaning the church, mowing the church grounds, and ringing the bell at six o'clock all year round.

Following the cessation of hostilities at the end of the First World War, money was raised by public subscription and in 1922 a new church clock was purchased as a fitting war memorial. The firm of G. J. F. Newey of York made and installed the clock.

In both 1872 and 1915 additions to the churchyard were consecrated. The War Memorial Chapel has an armed forces memorial window by Harry Stammers which dates from 1946. The woodwork by Kilburn dates from 1950.

There are four war graves in the churchyard. Those of Private Charles Harold Atkinson of the 52nd Bn of the Canadian Infantry, who lost his life on 6 February 1919; Guardsman John Frank Hinchcliffe of the 2nd Bn of the Coldstream Guards, who lost his life on 6 June 1940; Private Charles McCartney of the 1st Bn of the Duke of Wellington's (West Riding Regiment), who lost his life on 21 August 1940; and Gunner Sidney Daniel Hall of the 6th Bn Royal Artillery (the West Yorkshire Searchlight Regiment), who lost his life on 18 August 1944.

The Hemingbrough Mort Stone can still be seen by the roadside. Mort stones were a regular feature in isolated communities, when coffins had to be carried long distances before burial. The stones afforded some respite for weary coffin-bearers. Today, the ravages of time have taken their toll on the limestone block.

**Location: YO8 6QE**

## 17. St Michael and All Angels, Coxwold

There is documentary evidence that there was a church at Coxwold as early as 757. During that year Pope Paul I issued a papal charter to King Eadberht of Northumbria which ordered him to make some necessary repairs to three minsters: York, Ripon and Coxwold. The inclusion of Coxwold gives an indication as to the importance of the church at that time.

When the Anglo-Saxon church was replaced by a Norman church, oversight of the church was granted to the priory and convent of Newburgh on its foundation in 1145 by Roger de Mowbray and confirmed to them by Pope Innocent III in 1199. The ministry was provided by the priory until the Dissolution of the Monasteries by Henry VIII. On 4 November 1546, Henry granted the priory and its estates to his chaplain and commissioner, Anthony Belasyse. In 1547 the rectory with the advowson was granted to the Master and Fellows of Trinity College, Cambridge. Then, from the time of the Commonwealth up until 1839, the rectory and the advowson were held on lease by the lords of the manor of Coxwold. From 1839 until 1899 the right of presentation was exercised by Trinity College and, subsequent to that, by the Archbishop of York.

The current church, which replaced the earlier Norman church, was built between 1420 and 1430 and follows the Perpendicular style of architecture, although the chancel was rebuilt in 1777 and it was probably at that time that the tongue-shaped altar rail was added. The unusual shape of this rail was so more communicants could be accommodated during the service. Many attribute its design to Laurence Sterne, but this has never been verified.

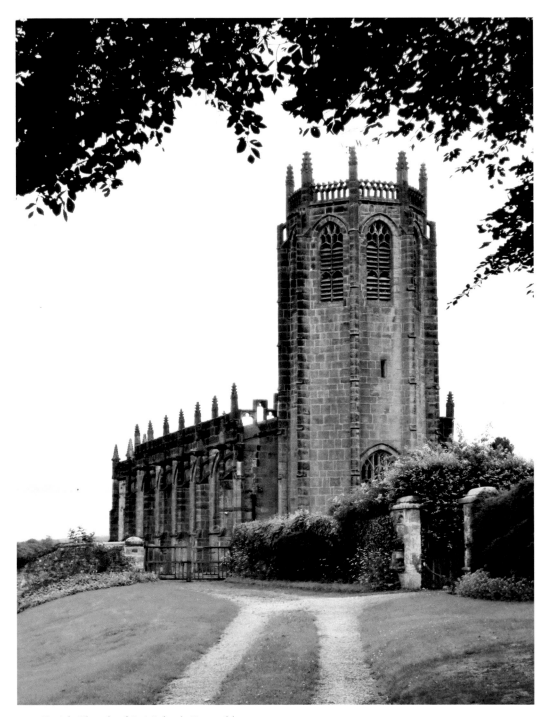

Parish Church of St Michael, Coxwold.

Georgian pulpit with a tester in the nave.

St Michael's has a nave, chancel, south porch, and a very rare octagonal west tower. There is a modern doorway in the westernmost of the three southern bays. Also, there is a Georgian pulpit with a tester in the nave. The church still retains the previously favoured eighteenth-century box pews which face the celebrant. It is believed that this layout was also devised by Laurence Sterne.

The organ is housed in a wooden gallery in the western part of the nave. There is a flat oak-panelled ceiling in the chancel, and, although the nave ceiling is a relatively recent renovation, it still retains some of its old, moulded timbers. The modern east window has three lights under a traceried four-centred head. In 1912, a window was inserted in the south wall of the chancel.

The royal coat of arms of King George II can be seen over the chancel arch, with the Fauconberg coat of arms on either side. At the north-east of the chancel there is a monument to William Bellasis, who died in 1603. He is depicted in a recumbent position next to his wife, Margaret. There is also a marble tomb to Barbara, daughter of Henry Cholmeley, and wife of Thomas Bellasis Viscount Fauconberg and Baron Yarm. The tomb has the kneeling effigies of the viscount and his lady. The white marble monument in the north-west is to Henry Bellasis, son of Thomas Viscount Fauconberg, and to Thomas Bellasis Earl Fauconberg,

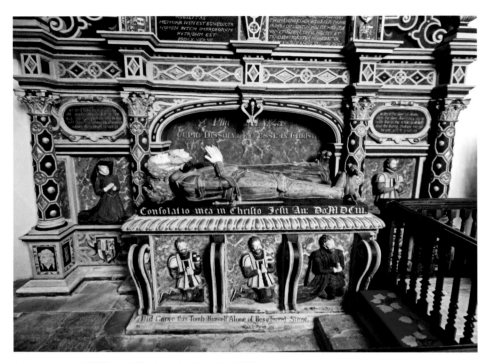

Monument to William Bellasis, who died in 1603.

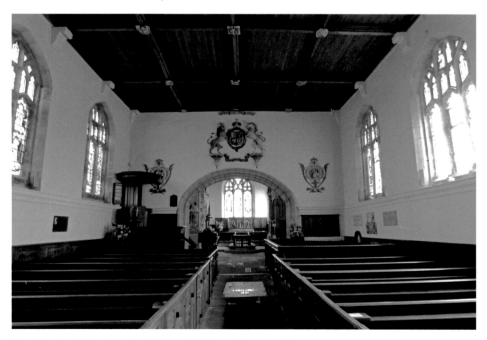

The church still retains the favoured eighteenth-century box pews.

who died in 1700. The modern Gothic monument in the south-west is to Henry Bellasis, Earl Fauconberg, who died in 1802.

Elizabeth Faucon is commemorated by a memorial stone on the east wall of the porch. Elizabeth was the daughter of the rector and patron of the church of Bainton.

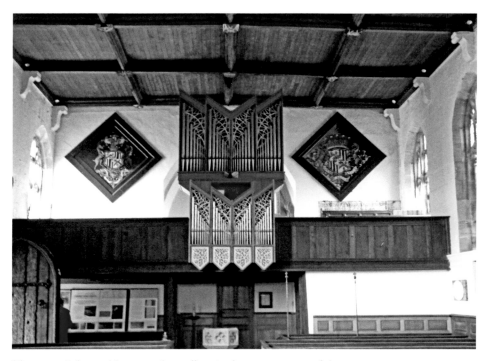

The organ is housed in a wooden gallery in the western part of the nave.

The royal coat of arms of King George II can be seen over the chancel arch.

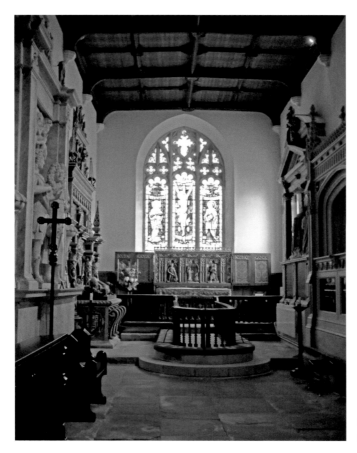

Unique tongue-shaped
altar rail added in 1777.

The traceried heads of most of the nave windows still retain their original fifteenth-century glass in good condition.

The oldest of St Michael's three bells is the tenor, which was probably cast towards the end of the sixteenth century. The bell bears the inscription 'fiat volvntas tva pater omnepotens', written in Roman characters. The second bell, cast in 1652, has the inscription 'Soli Deo Gloria Pax Hominibus'. The third bell, the treble, was cast by Pack & Chapman in 1771.

The visitors' book holds the signature of Queen Mary and, being in North Yorkshire, there are four wooden mice, carved by Robert 'Mouseman' Thompson.

The church plate includes two cups with covers, both of which are inscribed 'Coxwold'; one has no marks, but the other carries the York date mark for 1627, together with the maker's mark 'C.M.', denoting that it was made by Christopher Mangey.

While Revd Laurence Sterne was incumbent at St Michael's from 1760 until 1768, the remaining seven volumes of his novel *The Life and Opinions of Tristram Shandy Gentleman* were published. At the time he was living at the fifteenth-century parsonage, which he'd renamed Shandy Hall. The house where Sterne

lived alone was rented from the Fauconberg estate. With the acclaimed success of his books, it soon became apparent that Sterne was more concerned about following his literary career than continuing in his role as a country parson, so he employed a curate whose main responsibility was to fulfil his ecclesiastical duties in the parish.

When Sterne was paying a visit his London publisher in 1768 he was taken ill and died from pleurisy. He was buried near to Bayswater Road, but, just two days later, his remains were taken by body snatchers and sold for research. However, during the anatomical examination, the lecturer stopped the procedure shortly after the top of the skull had been sawn off, having recognised the cadaver as being none other than the famous novelist Laurence Sterne. The body was immediately re-interred. Then, in 1969, when the graveyard where Sterne had been buried for the second time was being sold, the Laurence Sterne Trust learned of the proposed sale and sought permission to exhume his body for reburial at Coxwold. He was buried for the third time in the churchyard beside the south wall of the chancel at St Michael's. His original gravestone can be seen inside the porch.

The Commonwealth War Graves Commission cares for the maintenance and upkeep of three graves of men who gave their lives during the First World War: Private William Cornforth of the 4th Regiment Royal Marine Light Infantry, who lost his life on 23 April 1918; Corporal William Whincup of the Royal Field Artillery, who lost his life on 5 January 1918; and Sub-Lieutenant C. H. Jones of the Royal Naval Volunteer Reserve, who lost his life on 30 October 1918.

Sir George Orby Wombwell, 4th Baronet, a survivor of the Charge of the Light Brigade, is buried in Coxwold churchyard. The lychgate at St Michael's was built in memory of another of his relatives, Captain Stephen Wombwell. There is a plaque inside the church dedicated to the memory of Captain Wombwell, who died of a fever during the Boer War.

**Location:** YO61 4AD

## 18. HOLY TRINITY, SKIPTON

The Domesday Book makes no reference to there being a church in Skipton, so it seems that a church did not exist in the town before 1086. The honour of Skipton was given to Robert de Romille by William the Conqueror, and it is probable that he was the founder of the church. It is thought that the original Norman church would have been constructed of wood, although the present structure, built with the help of monks from Bolton Priory, dates from the beginning of the fourteenth century.

The church was extended at the beginning of the fourteenth century, with the north and south aisles being added, as well as the clerestory. A tower was also added at this time. Today, the church of Holy Trinity has a chancel and nave together with a clerestory, a south porch and a north transept, which houses the organ and vestry. The chancel has the Lady Chapel to the south and in the north is the prayer corner. There are seven bays of arches.

At the time of the siege of Skipton Castle during the Civil War the steeple received rough treatment, said to have been caused by a stray cannon from hostile

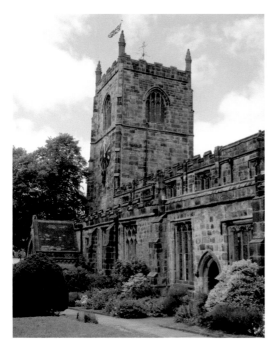 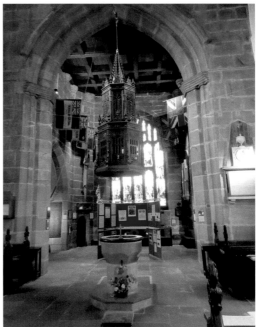

*Above left*: Parish Church of Holy Trinity, Skipton.

*Above right*: Font with Jacobean cover.

Parliamentary forces, when it was 'nearly beaten down by random balls'. The fabric, including the rebuilding of the tower, was restored thanks to the financial support of Lady Anne Clifford of Skipton Castle.

The church narrowly escaped being burnt down in January 1841 when woodwork near to stove pipes ignited. Fortunately, the fire was discovered very early and little damage was done. However, a far more serious fire occurred during the time of a service on Sunday 19 June 1853, when, at the height of a severe thunderstorm, the church was struck by lightning, causing the west pinnacle of the tower, weighing some 1.5 tonnes, to fall. The lightning, which ran along the roof, also caused damage to the chancel. As a result of the subsequent structural inspection, several beams in the nave roof were deemed to have been rendered insecure by the shock. Also, the pillars beneath the east gallery were reported as being in a poor state, the arches should be properly shored up, and all the five pillars underpinned. Further, the inspection found that a portion of the south side of the choir clerestory should be taken down and rebuilt as it was unsafe. It is estimated that the requisite repairs cost £1,470.

During the time of these repairs a concrete slab, in excess of 9 inches thick, was laid under the existing slabs in the main body of the church. The reason being that there were 'offensive odours being emitted from the vaults and graves below' – the space beneath the flooring of the church having been used for many years as a

*Above*: Marble tomb of Henry, 1st Earl of Cumberland.

*Right*: The magnificent east window with the Caen stone reredos.

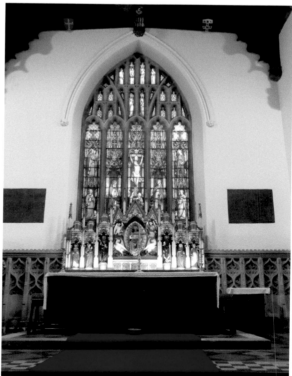

The stone seats of the
sedilia in the south wall
were provided for clergy
celebrating at High
Mass.

depository of the dead. When evening services were established in 1843 and gas
was introduced into the church, the air became rarefied by the warmth of stoves
and burning gas and rank vapours were drawn out in uncontrollable profusion.
The repairs and refurbishments having been completed, the church was reopened
on Wednesday 23 April 1856.

Before organ music was introduced in the church, the only accompaniment to
the musical portion of divine service was that of violin, bass viol and bassoon. In
1803 an organ, built by Lincoln of London, was obtained and an organ gallery
built. It was also agreed that 'the organist do receive the sum of £5 5s. per annum
for instructing children in psalmody', and that 'a certain number of singers, not
exceeding eight, attend to be taught, and to sing on a Sunday'. In January 1875
a new organ, built by Messrs F. W. Jardine and Co. of Manchester at a cost of
nearly £700, was added to the church. Unfortunately, on 8 April 1925 the church
roof was again struck by lightning, causing a fire that destroyed both the roof
and the organ. Following the repair of the roof by Austin and Paley a new organ
was installed. The new three-manual organ was designed by Edward Bairstow
and built by Rushworth and Draper of Liverpool. In 1966 and again in 1970

the organ was rebuilt by Laycock and Bannister of Keithley and reduced to two manuals. The organ was then moved into the left bay of the north transept.

Parish registers show that there were bells at Holy Trinity sometime before 1617. At the time of the Civil War there were five bells in the church tower, but they were taken as a prize of war. It was agreed that the bells could be redeemed for £200, but only four bells were subsequently returned. Lady Clifford, Countess Dowager of Pembroke, paid for their return, installation and the repair of the war-damaged tower.

At a vestry meeting in 1759 it was agreed that the bells should be melted down at the foundry of Leicester and Pack of London, additional metal added, and a peal of six new bells should be created. Today, the tower houses a fine ring of eight bells, with the tenor bell weighing just over 22 cwts. In 1921 all eight bells were recast, fitted in a new frame and installed by John Taylor and Co. of Loughborough.

The font, which has a magnificent Jacobean cover, stands to the west end of the nave.

Many of the stained-glass windows in the church are attributed to Jean-Baptiste Capronnier, the Belgian stained-glass painter. One of the windows depicts the baby Jesus in the arms of an aging Simeon. The west window, a memorial to those who died in the First World War, is by Shrigley and Hunt of Lancaster.

When the tower clock of 1835, made by Titus Bancroft of Sowerby Bridge, replaced the old clock, some conditions as to its manufacture were stipulated: 'The clock to strike quarters upon the first, third, and fifth bells, and the hours upon the fourth and sixth bells, with all necessary appendages agreeable to the specifications; to be fully completed within nine months, for the sum of one hundred and sixty pounds, to be paid when the work is done, and no charge to be made for any extras.' The clock has two dials: one on the south and the other on the west side of the tower. The dial plate on the south side is circular and that on the west is octagonal.

The south porch, which replaced a very old porch, was erected in 1866 by Mr John Robinson of Ravenshaw, near Skipton, in memory of his first wife, Susan. The porch, built after the Gothic style, was designed by Mr Lowe of Manchester.

In June 1874 Mrs Alcock and her family had a handsome reredos erected in the church in memory of her late husband, Mr Henry Alcock. The reredos, of Caen stone and costing about £1,000, was designed by Sir Gilbert Scott and depict Christ in Majesty surrounded by symbols of the Four Evangelists.

There is a large number of monuments of one sort or another within the church of Holy Trinity. Following the dissolution of Bolton Priory, the chancel became the burial place of the Cliffords of Skipton Castle, the tombs standing within the Communion rails. On the right of the altar is the tomb of George, 3rd Earl of Cumberland. The tomb was erected by Lady Anne Clifford, his daughter. The marble tomb to the left of the altar is that of Henry, 1st Earl of Cumberland. The smaller tomb in front is that of Francis, Lord Clifford, the young brother of Lady Anne, who died aged five. There is a vault directly beneath the altar.

**Location: BD23 1NJ**

## 19. St John the Baptist, Stanwick

It is recorded in the Domesday Book of 1086 that there was a church at Stanwick at that time, although archaeological remains, such as the medieval tomb slabs in the porch or the two hogback memorial fragments built into the walls of the porch which date to the early tenth century, would suggest that the church referred to as 'Aldbrough' in the Domesday Book was in fact the Church of St John the Baptist at Stanwick, and, conceivably, could have formed part of an earlier Anglo-Saxon parish.

The Church of St John the Baptist is located within the earthworks of an Iron Age camp. During the first century AD Stanwick Camp was an important trading centre.

The circular shape of the churchyard indicates that it was an established feature before the Norman Conquest, although the present church, rebuilt in the Early English style of architecture, only dates from the thirteenth century.

In 1868 Eleanor the dowager duchess of Northumberland had the Church of St John the Baptist entirely rebuilt at her own expense. The major works were directed by the English architect Anthony Salvin. Many of the Arts and Crafts fittings in the church date from this period, as does the tiled reredos behind the altar.

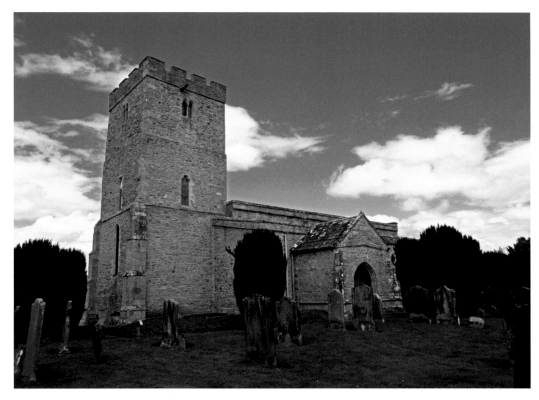

Parish Church of St John the Baptist, Stanwick.

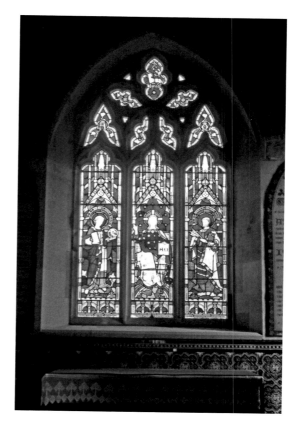

East window, representing Our
Lord in His Glory, with St Peter and
St John on His right and left sides.

In plan, the church has a four-bay nave with a south aisle and a south porch.
In the nineteenth century a north vestry was added to the three-bay chancel. The
church has a three-stage west tower. The lowest stage has a lancet window above
a central buttress on the west face and there is a similar lancet window on each
face of the middle stage. The top stage has two-light bell openings, and the summit
has a battlemented parapet.

Located directly under the church tower the back of the nave are the remains of
a ninth-century Anglo-Saxon Viking ring cross with engraved scrollwork. Typical
of the period, the cross has interlaced designs showing entwined beasts. Also, there
is still some evidence of an earlier Norman church that occupied the same site.
The present church predominantly follows the Early English style of architecture.

Octagonal pillars with pointed arches separate the nave and side aisles. There
are also funerary monuments, including three hatchments that hang above the
arches and are for members of the Pulleine family and the 2nd and 4th Earls of
Northumberland. Above the chancel arch, the church also displays the royal coat
of arms of King George III.

Set into the south wall of the chancel is a Gothic-style triple sedilia and a piscina
which date to the Victorian era. The sedilia was specifically reserved for officiating
clergy.

*Above left*: Remains of a ninth-century Anglo-Saxon Viking ring cross with engraved scrollwork.

*Above right*: St John's organ was built in 1866 by John Fincham of Euston Road, London.

Of the church's four recumbent effigies, one is to be found in the south aisle on the ledge of the east window. This effigy shows a woman with her hands joined in prayer. At the end of the south aisle, marble effigies of the first Sir Hugh Smithson and his wife are to be seen, recumbent on the seventeenth-century Smithson tomb. Sir Hugh, who died in 1670, is shown regaled in full armour, whereas his wife is shown dressed more simply and holding a book of some description. There is a mural monument to Sir Hugh Smithson, 3rd Baronet, and many seventeenth- and eighteenth-century funerary monuments to members of the Smithson family. There is a recumbent effigy in the north wall of the chancel. Many years later, the Smithsonian Institute in Washington was established by the Smithson family.

A number of carved Anglo-Saxon stones have been incorporated into the fabric of the south aisle, and in the south wall there is a nineteenth-century single-light west window, two three-light windows also dating from the nineteenth century and a thirteenth-century east window.

The church has three two-light windows in the north wall and a two-light nineteenth-century window in the vestry. There is a priest door in the chancel and a number of windows, including a three-light east window that dates from 1868.

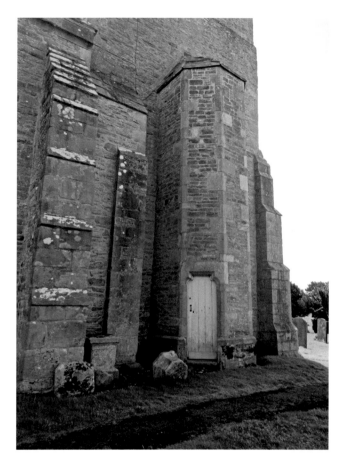

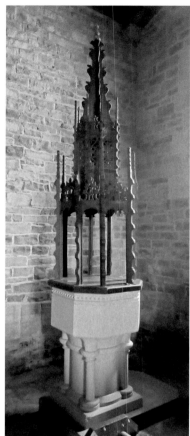

*Above left*: The five-sided stair turret on the north side.

*Above right*: The nineteenth-century octagonal stone font is topped with a three-tiered, Gothic-style wooden cover dating from the seventeenth century.

*Right*: The recumbent marble effigy of the first Sir Hugh Smithson and his wife seen on the seventeenth-century Smithson tomb.

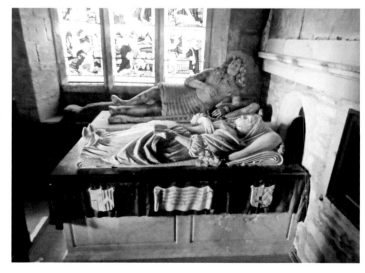

The lights in the east window were manufactured by the London glass studios of Clayton & Bell and represent Our Lord in His Glory with St Peter and St John on His right and left sides. The window was inserted in memory of the late Duke Algernon by his tenants and friends. On either side of the window there are boards with the Lord's Prayer, the Creed and the Ten Commandments written on them.

Another stained-glass window has been inserted to the memory of Dr Walker of Aldbrough by his widow and children. The window depicts the parable of the Good Samaritan, the prophet Elisha, and St Luke in his twofold calling of physician and evangelist. There was once a fifteenth-century brass in memory of Emma, wife of Sir Ralph Pudsey, but this has now been removed. There are also a number of large, fourteenth-century windows in the Decorated style in the church.

On the west side of the church there is a medieval stone coffin lying on its side. A five-sided stair turret on the north side was added during the nineteenth century. There is a sundial over the porch's arched doorway. The nineteenth century octagonal stone font is topped with a three-tiered, Gothic-style wooden cover dating from the seventeenth century. The organ at St John's was built in 1866 by John Fincham of Euston Road, London.

The church has a ring of three bells, all of which were cast at the foundry of Samuel Smith of York and bear the following inscriptions: No. 1, 'Venite exultemus Domino 1677, SS. Ebor'; No .2, 'Gloria in altissimis deo 1677, SS. Ebor'; and No. 3, 'Glora in excelsis deo 1685, ih, pw churchwardens SS. Ebor'.

The English engraver Herbert Francis Wauthier is credited with designing the First World War memorial.

**Location:** DL11 7RT

# Acknowledgements

I would like to thank the many people who have assisted me in collecting and collating information with regard to the historic churches recorded in this text. I would especially like to thank Susan Sellers, Mr John Banks, Mr John Grant, and Mrs and Mr James Grisedale. I would also wish to thank my wife, Janet, for accompanying me when taking photographs, and my son, Jon, who read and made a number of useful corrections to the manuscript.

Finally, while I have tried to ensure that the information in the text is factually correct, any errors or inaccuracies are mine alone.

# About the Author

David Paul was born and brought up in Liverpool. Before entering the teaching profession David served as an apprentice marine engineer with the Pacific Steam Navigation Company.

Since retiring, David has written a number of books on different aspects of the history of Derbyshire, Cheshire, Lancashire, Yorkshire, Shropshire and Liverpool.

Also by David Paul

*Eyam: Plague Village*
*Anfield Voices*
*Historic Streets of Liverpool*
*Illustrated Tales of Cheshire*
*Illustrated Tales of Yorkshire*
*Illustrated Tales of Shropshire*
*Illustrated Tales of Lancashire*
*Illustrated Tales of Derbyshire*
*Speke to Me*

*Around Speke Through Time*
*Speke History Tour*
*Woolton Through Time*
*Woolton History Tour*
*Churches of Cheshire*
*Churches of Shropshire*
*Churches of Lancashire*
*Churches of Derbyshire*
*Churches of Southern Yorkshire*